War Is Only Half The Story

THE AFTERMATH PROJECT
Volume 1
Jim Goldberg, Wolf Böwig
Paula Luttringer, Asim Rafiqui, Andrew Stanbridge

 METS & SCHILT aperture THE AFTERMATH PROJECT

WAR IS ONLY HALF THE STORY

Sara Terry
Founder, The Aftermath Project
www.theaftermathproject.org

Six words that sum up what The Aftermath Project is all about. And here in this volume, the first of an ongoing series, you will *see* what The Aftermath Project is all about. These images and stories represent the work of the first two Aftermath Project grant winners, and of the three finalists for those inaugural grants. Together, they give a broad and incisive view of the aftermath of conflict, of the kinds of stories that all too often go untold – the kinds of stories that must be told if we are ever to understand the true cost of war and the real price of peace.

It's been nearly five years since I came up with the idea of starting a grant program to help photographers cover the aftermath of war. I was still in the midst of my own long-term project about the aftermath of war in Bosnia and I was wrestling with the realization that one project about the aftermath of the Balkans conflict wasn't going to go a long way in trying to change the way the media covers war, or in challenging simplistic ways of thinking that seemed to equate the end of violence with lasting peace.

I'd started the work in Bosnia out of sheer exasperation. Five years after the end of the war there – a war marked by 'ethnic cleansing' and genocide – I was reading a newspaper article that said that just as many Bosnians were finally feeling safe enough to try to return to homes they had fled during the war, the international community was getting Bosnia 'fatigue' and moving on to the next crisis spot, which at that time was East Timor. The result? Only twenty percent of the Bosnians who wanted to go home would receive the much-needed aid to make those brave returns – despite the fact that facilitating this return was one of the stated principles of the peace accord that ended the war. I found it hard to believe that the international community could be so shortsighted in committing itself to helping build a lasting peace. I set out, six weeks later, on my first trip to Bosnia to try to be a truthful witness to the ongoing struggle of a country trying to move beyond the shadow of war.

During the years that followed, I realized that at the root of my work was a desire to change the way we tell the story of conflict – to be part of creating

I found myself thinking about the possibility of a world in which photographers would be able to pursue the story of peace as rigorously as they have pursued the story of war for more than a century.

a new dialogue about war, in which telling the story of aftermath is as important as telling the story of war itself. I found myself thinking about the possibility of a world in which photographers would be able to pursue the story of peace as rigorously as they have pursued the story of war for more than a century. I imagined a changed media environment in which those who told those stories were supported and recognized through assignments and awards – an environment, in other words, which recognized the 'news' in aftermath.

And so I came to the idea of founding The Aftermath Project. From the beginning, it has been an idea that has been readily embraced by many people – many of whom have played important and generous roles in bringing this project to life and who have added their own vision for what it can accomplish. I often think of what Jan Eliasson said when he agreed to be one of the first members of the advisory board, in the very early stages of creating the grant program. A former deputy secretary general of the United Nations who was then Sweden's ambassador to the United States, Eliasson said he was drawn to the project because it was about more than the story of war. He believed that in drawing attention and resources to aftermath situations, the result could actually be conflict prevention, instead of the endless rounds of conflict resolution that consume so much of the world's time and energy today.

It remains to be seen, of course, whether Eliasson's convictions will prove to be true. We are still only at the beginning of this work, still trying to shape conversations and build networks and support for creating long-term change in the way that the media tells the story of war – and in the way that the rest of us understand what it takes to build peace.

In the meantime, the other half of the story of war is unfolding every day, all over the world. It is our hope to help bring those stories to life.

In this volume, you'll see the work of our first two grant winners, Jim Goldberg and Wolf Böwig. Goldberg, who is widely recognized as a true innovator in the documentary field, won the 2007 first-place Aftermath grant for his project The New Europeans, a work in progress which depicts the daunting challenges faced by refugees, migrants, asylum seekers and trafficked people, and their indomitable will to survive and create new lives.

Photographer Wolf Böwig has covered conflicts around the world for more than fifteen years. With his Aftermath grant, he returned to Sierra Leone, to tell the story of Morie, who, as a five-year-old, was the sole survivor of a massacre during that nation's brutal war.

You'll also see the work of our three finalists: Andrew Stanbridge (postwar reconstruction in Laos); Asim Rafiqui (Haiti's ongoing aftermath and continuing political violence); and Paula Luttringer (a survey of sites in Argentina where women and their children were abducted between 1976 and 1983).

Together, these five photographers launch a rich, inaugural conversation about the many facets of aftermath. Each of them has a distinct visual voice and narrative structure, but all of them clearly understand that war is only half the story.

We hope you will join us in the conversation.

THE AFTERMATH PROJECT

Simon Winchester

Though war may have been defined by Carl von Clausewitz as a continuation of politics by other means, the battles that configure it, however awful and tragic they may individually be, are undeniably the stuff of great spectacle. From the longbows of Crécy to the cavalry charges of Crimea, from the trench-fighting of Ypres to the roadside bombs of Baghdad, the matter and mechanics of the pitting of man against man has always possessed a terrible nobility, and writers and artists and photographers and filmmakers have been just as attracted to the rhythms of state-hatred as to their very antithesis, the poetry of human love. But war, like Gaul, is divisible into three parts – of which the actual battling, the ferocious and most popularly recorded aspect of the phenomenon, is but one. The consequences of war are an obvious second, and just as the actual fighting can often be about majesty and spectacle and sometime heroism, so its consequences are all too often heroic also, though on a far, far grander scale. They become, most often, a matter of record: history takes note of the causes of war and then it records what the war itself caused, eventually consigning the results to the atlases and archives, and, of course, to the history books themselves.

Examples are legion: in the young America of the mid-1860s, anger and separatist fury provoked a Civil War that pitted the South against the Union; its battles were momentarily memorable, those that were photographed or filmed made even more so. But it was the consequence of that war – that of the establishment, once and for all, of a properly united United States, with universal emancipation, and to be run as Lincoln most eloquently wished at Gettysburg – that was the legacy of the greatest importance. The war itself had spectacular moments, true, but it is the consequence of that war that has subsequently been etched and carved onto the historical record of our planet, and so has become a much greater moment than the battling itself. And as with the American Civil War, so with a thousand other conflicts. With the fighting done and a peace resumed, there were all manner of results: nations were born, empires were dissolved, frontiers were created, tyrants were toppled. History notes such results forever: the fighting itself fades into anecdote, to become the stuff of distant memory.

But there is a further dimension to this story, the occasional surfacing of a third aspect to war, and one that doggedly remains something of a mystery. It is a dimension of the fighting to be found lurking in the interstices of the greater narrative, something that is almost furtive, fugitive, secret. It is what lies between War and the Consequence of War – or, if you like, it is what lies, half-hidden, between War and Peace. For in the unholy trinity of conflict there happens to be a time, an interregnum – sometimes mercifully brief, more often tragically long and drawn-out – that exists within the historical continuum, but which is frequently ignored, or at least is more generally overlooked. It is an expanse of time that lacks both the spectacle of battle, and the gravitas of consequence. It is the time when the writers go home, when the artists fold up their easels, when the cameras are put back in their cases – and yet the time before the statesmen stop by to assess, to decide and to divide up the spoils, to sign the treaties and draw the borderlines and lay the foundation-stones for the hardware of history. It is a period that can rightly be regarded as the temporal no-man's-land of the conflict. This – as the authors and editors and contributors to this book have so bravely decided to recognize – is the unsung and in-between third part of war: the Aftermath. The word itself is only just appropriate.

Math is an extremely ancient word for mowing, and the literal meaning of *aftermath* is the appearance of a new growth of corn or barley in a field that has just been cropped. The word in its early sense had a positive and generally agricultural meaning: cows, it used to be said, look forward to eating the aftermath. It was only in the nineteenth century that aftermath took on its currently insalubrious meaning – the condition that follows a (usually unpleasant) event. It was Winston Churchill who first applied this definition to warfare, writing in his massive memoir on Victory in 1946 that 'Britain's will would be tested not only in the war, but in the aftermath of war.'
That particular aftermath was one I remember all too well – for if the journalists and the statesmen have a habit of overlooking this phase of conflict, those who are caught up in it have it firmly annealed into their souls for as long as they live.

I was born in London in 1944, and so far as my direct involvement in World War II was concerned, it was necessarily limited, and certainly not at all heroic: a v-bomb half-demolished a house in our street, and I was evacuated with my justly alarmed mother to a rural town fifty miles away from the dangers of the capital. But it so happened that my father had been captured in Normandy soon after D-day, unaware that the wife he had left behind was pregnant. And when we met for the first time, after he had been released and demobilized, I was already six months old. And that, in a sense, was part of our experience of this war's aftermath.

It seems that the rigors of the aftermath phenomenon have been worsening as the years of conflict have wound on – with the phase being in so many conflict zones now anything but trivial, and yet just as comprehensively overlooked as it always was.

For the enforced separation of families, with all of separation's concomitant emotional and psychological effects, is a common phenomenon of war often made notoriously visible in the lines of refugees and in the camps of battle-displaced persons. Here in London it was the same for us, but very much less dramatic. My father's disappearance and long-delayed return from Germany was to have a direct effect on all three of us in our tiny nuclear family – but as with nearly all aftermath issues, it remained unremarkable and unsung, a picayune result of war that was rightly of little interest and little importance other than to those of us who it most directly affected. Other signs of the aftermath were a bit more obvious. There were the bombing sites where we played as small children – the gaping holes in city streets where Luftwaffe hundred-pounders had fallen, and the places where we sailed our toy boats, around the shattered columns and shards of rusted iron that broke surface in the pools left under the broken water mains. There were the one-legged young men, pale and unaccustomed to their new army-issue crutches, limping to the employment exchange to look for work. There was one man I remember as if it were yesterday: Whistling Willie, they called him, a forlorn and broken man who blew tuneless dirges into the air, and doddered, hare-eyed, outside the pub each morning, waiting for it to open. Shellshock, the neighbors said, pityingly. He had been at Bastogne,

5

or El Alamein, and had been driven mad by the endless cannonades of the howitzers, and now would never be the same.

And then there was rationing, still. The Atlantic convoys had taken their time to resume, and so almost every kind of food that came to Britain by ship – sugar, tea, meat – was 'on points,' and my mother and a million others like her would scrimp and save and make do with egg powder or a quarter-pound of flour each week, or bake pies made with potatoes and nothing else. I remember listening to the bell in my boarding-school quad pealing on the one mid-Fifties midnight that we knew signaled the end of all rationing – whereupon our entire dormitory of ten-year-olds whooped for joy at the realization that the war we never truly knew was now over, forever.

The aftermath of war in England was thus generally trivial – a brief and slightly annoying period of mild madnesses and disabilities and shortages and temporary separations, a time suspended irrelevantly between such epic bookends as the Battle of the Bulge (an example of heroic and much-photographed fighting) and the Fall of Hitler (the most profound of the many profound consequences that proved what the fighting was for.) The exigencies of our particular aftermath were nothing – except to those of us who had to endure them – compared to the more dreadful problems that are endured elsewhere, and, ominously, that are being suffered so much more acutely and more often in more recent times. It seems that the rigors of the aftermath phenomenon have been worsening as the years of conflict have wound on – with the phase being in so many conflict zones now anything but trivial, and yet just as comprehensively overlooked as it always was. I think I first realized this one day in northern Macedonia, in the summer of 1999. The Serb armies had at the time been expending their ethnic-cleansing energies on the Kosovar Albanians, and I recall, with a still vivid horror, landing in a helicopter in a water-meadow that was thick with people, all of them refugees. The field held vast crowds of Muslims who had been forced, by bayonet, and attack dogs, and threats of the vilest kind, to leave Serbia and find homes elsewhere. In time a war was fought over the issue: NATO planes and troops bloodied the noses of the Serbs and forced a kind of peace in Kosovo. For a while it was tempting to think that the aftermath of that conflict was largely physical, limited to the buildings that had been shattered and needed to be rebuilt, the bridges and the radio stations and the schools and hospitals that needed repair and rehabilitation.

There is nothing cool, nothing sexy, nothing attractive about the aftermath of war. Aftermath is a phenomenon that is utterly lacking in epic qualities.

But it was actually the people – the terrified, traumatized, brutalized people in that field – who represented the real and long-forgotten aftermath of Kosovo. Few of those thousands in that terrible Golgotha ever dared to go back home, no matter the assurances of the soldiers from NATO or the bureaucrats who were sent in to reconstruct their state. Instead, they fanned out in vast hordes across a briefly sympathetic Europe, to form an Albanian

diaspora that today is reviled and mistrusted and accused and marginalized, just like so many other diasporas that have been created out of the postwar ruins of a myriad half-forgotten conflicts. One sees today a thin and sallow windshield washer at a Frankfurt freeway exit, or passes a street-tanned drifter at a London railway terminus, and one instinctively mutters 'Albanian' under one's breath, and turns away. Few will care to remember the Kosovo conflict any longer, few will know that these hapless people are the flotsam of that bitter little war's aftermath, and few will offer sympathy or care.

The merit of The Aftermath Project and the accompanying publication that follows is that some of the world's most interesting and sympathetically creative photographers are committed – and supported in this commitment – to offering up for our examination examples of this human face of war's aftermath, in a noble attempt to wake us up to the realization that the physical wreckage of the fight is all too often accompanied by human wreckage. Realization may be a fact that this project will help instill; recognition, however, is another matter. In America a generation of Vietnam veterans represents the aftermath of that long ago fight, and today a new generation of Iraq veterans may soon be filling much the same role – with both groups recognized, though neither winning more than a nod of sympathetic acknowledgment from the general American public. For others in less advanced societies it is far, far worse. Who in the world cares today for the limbless Sierra Leonians? Who now frets for the condition of displaced Rwandans? Is any politician today seeking justice for the broken-minded victims of the Khmer Rouge? And for those unhappy thousands who flood a Europe that once seemed a bastion of liberalism and tolerance for so many, who truly ever wonders now what it was that they went through, what brought them so low, and who cares for their future?

There is nothing cool, nothing sexy, nothing attractive about the aftermath of war. Aftermath is a phenomenon that is utterly lacking in epic qualities. Epic films are made about great battles. Epic books are written about great treaties. Epic treatises discuss the tides of history. But of those caught up in and then laid waste by the conflicts that lie at the hearts of these epics, there is nothing. No Hollywood mogul will ever care to chronicle the wreckage that war brings in its train: he wants the battle, or he wants the history, not the orphan-child stranded in between.

This publication attempts, carefully and compassionately, to set the record straight. It does not offer easy reading, nor does it make for easy viewing. But it is right and proper that we should read and that we should look if the vision yielded by simply doing so offers even the faintest hope that we might briefly stop the fighting and consider not just the causes and the consequences of war, but the innocent human beings stranded by its undertow. They are, after all, people just like ourselves, people who have the misfortune to be caught up and crushed between spectacle and consequence, in the halfway world that is now made so eloquently visible in the pages that follow.

THE NEW EUROPEANS (working title)

Jim Goldberg

BOOK # 1

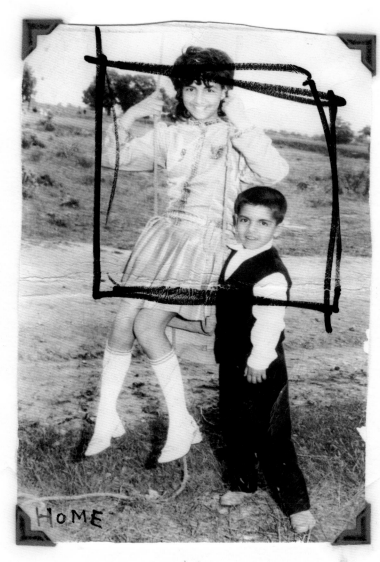

HOME

← SMALLER?

↑

TITLE "THE ROAD WEST"?
INSTEAD OF 'HOME'.

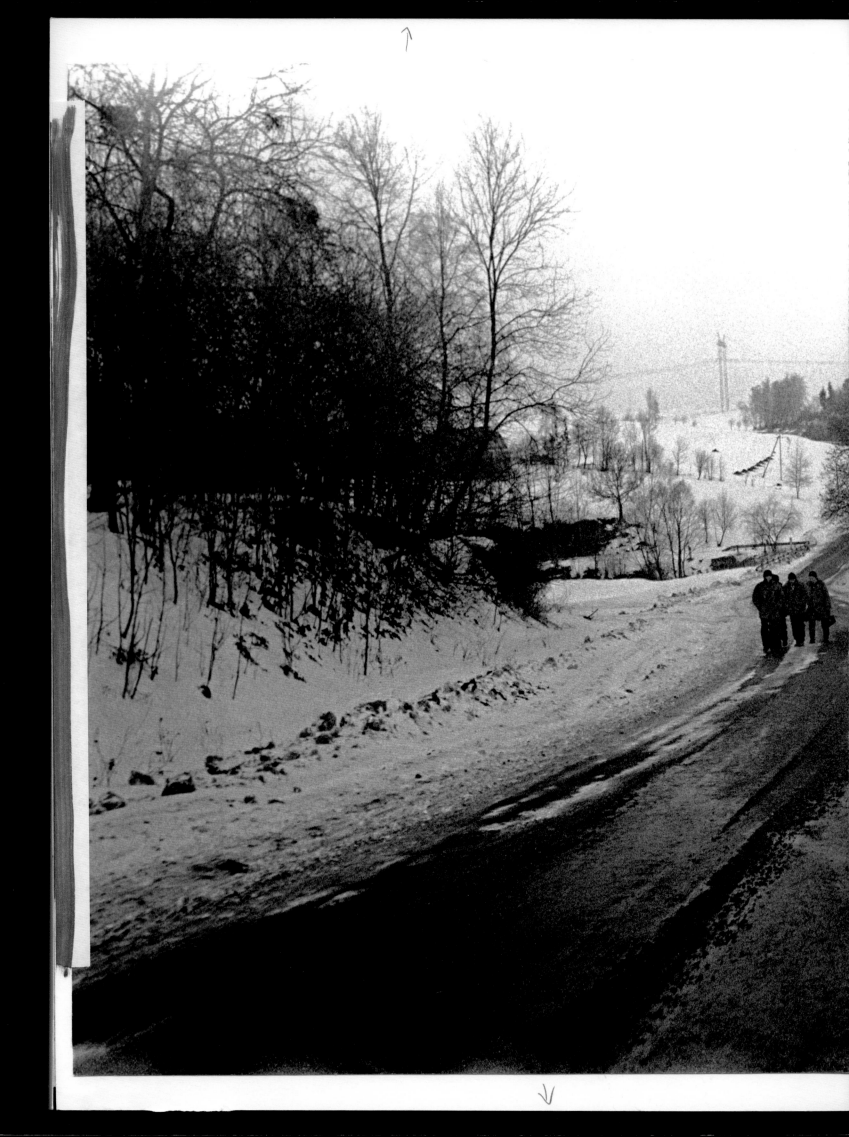

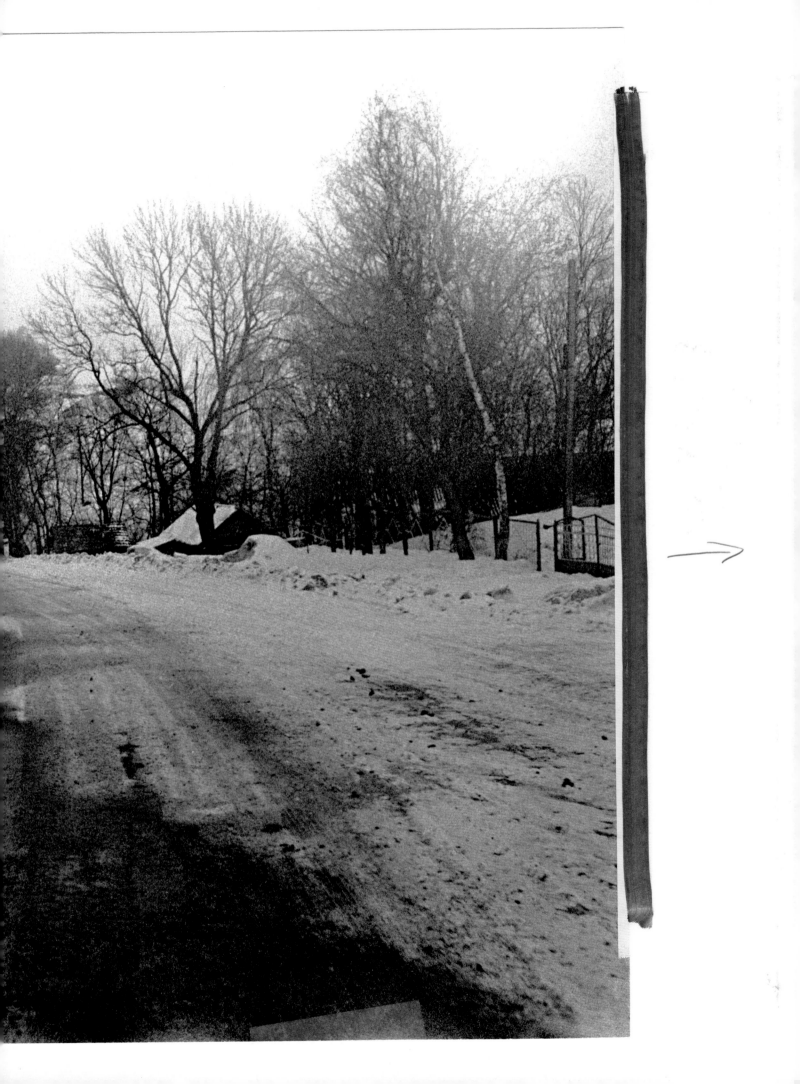

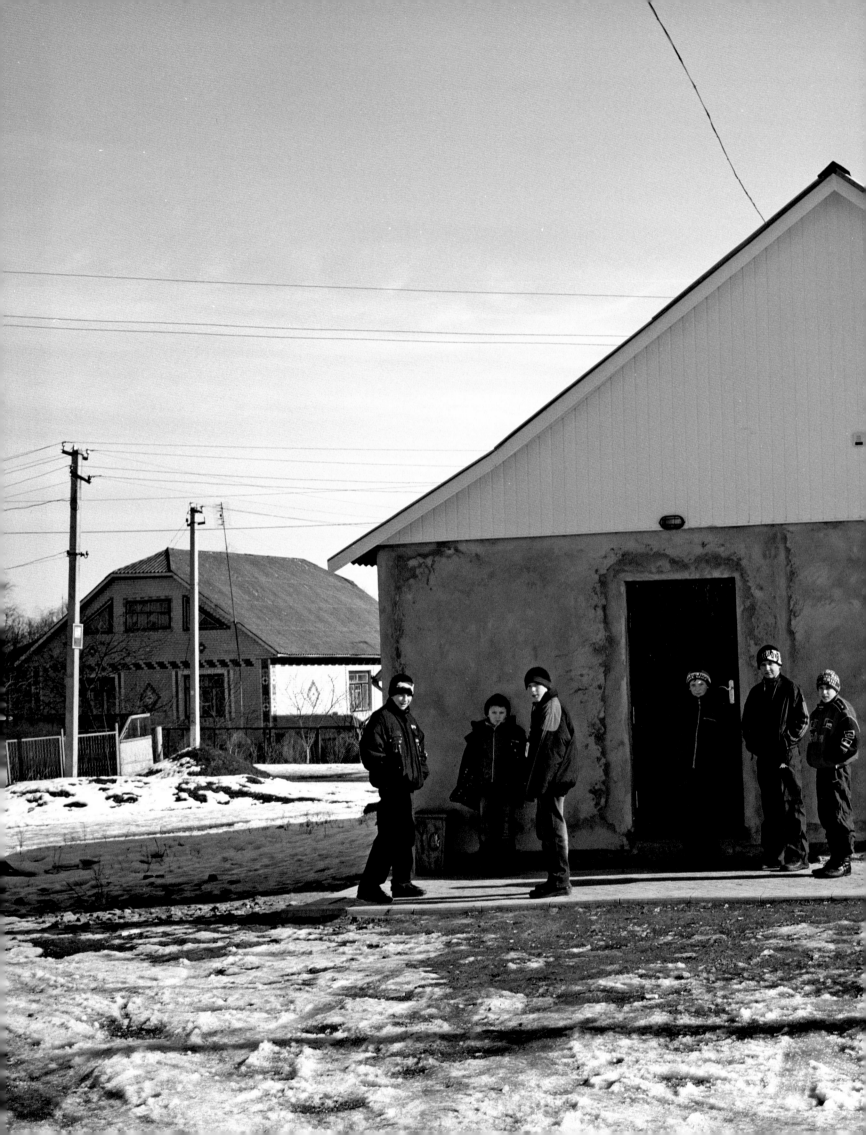

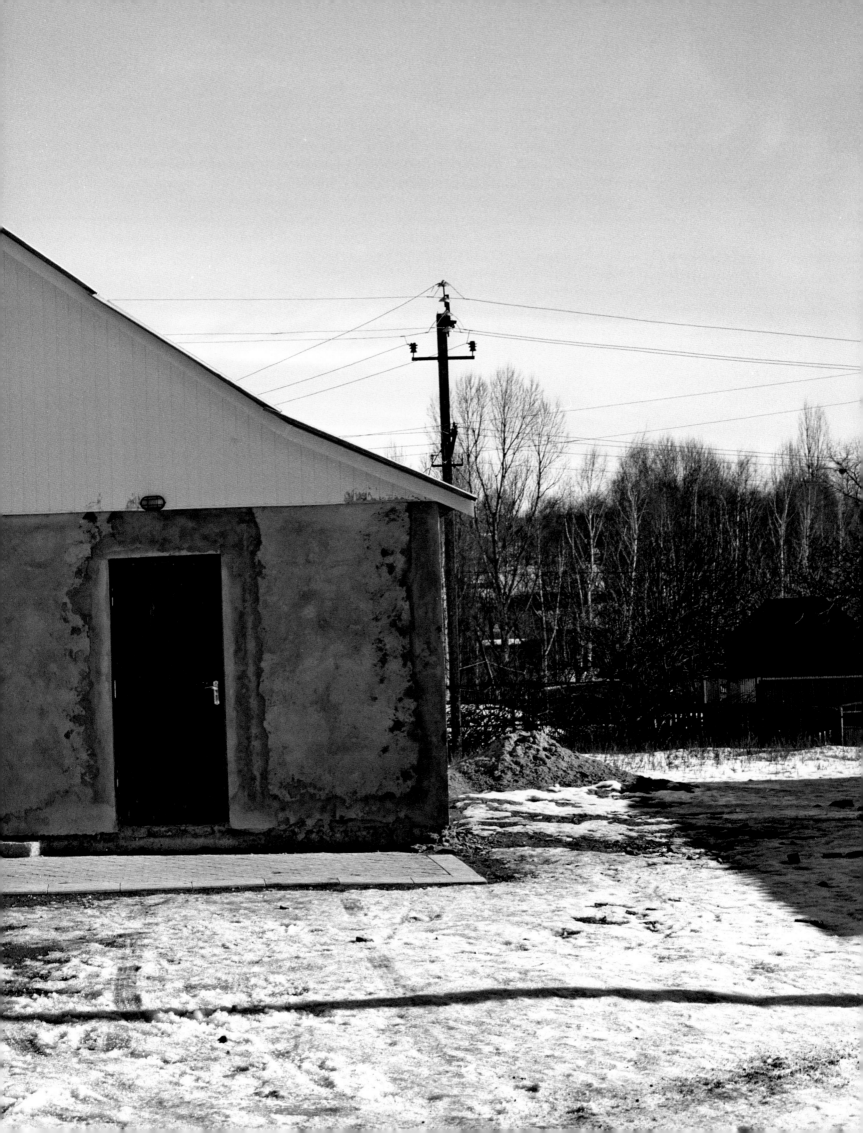

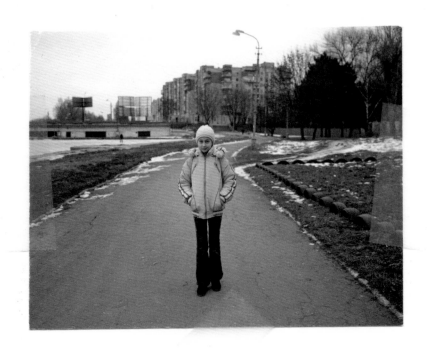

 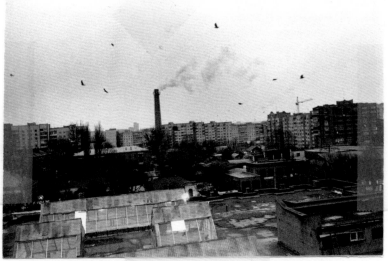

MOVE?

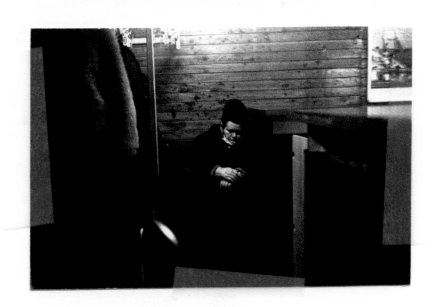

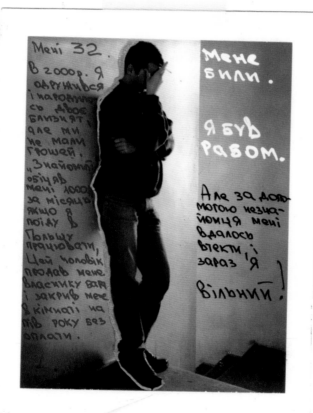

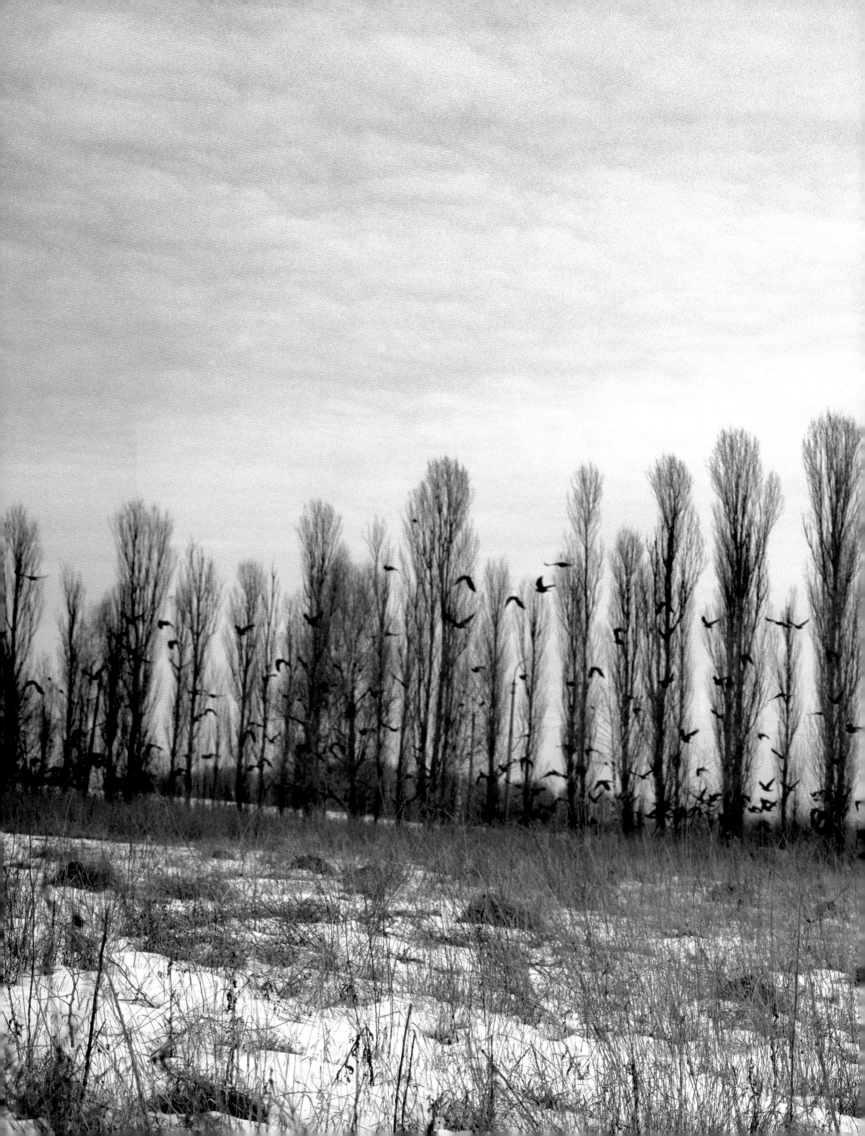

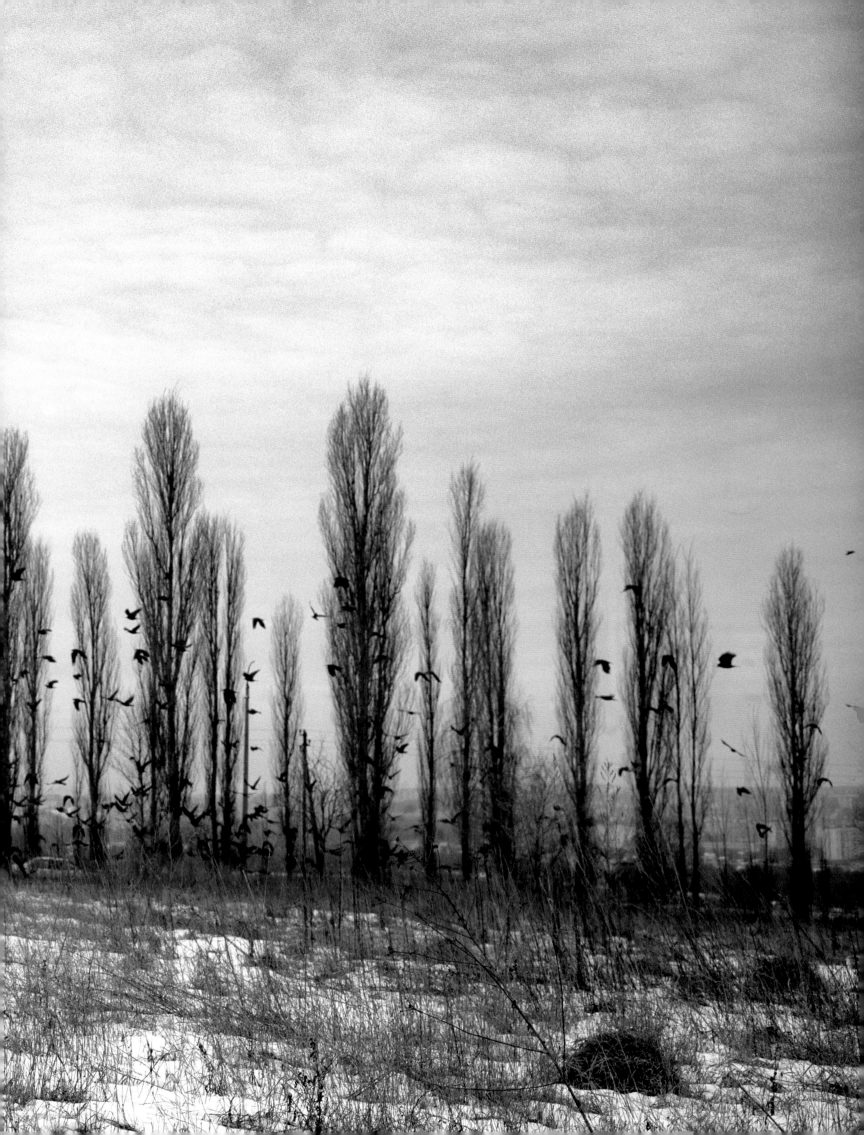

Tanya

In 2006, I read an advertisement in the newspaper that said 'Waitress needed in Germany.' I went to the agency and applied; they lent me 2,000 Euros for the papers and a bus ticket to (Hanover) Germany.

When I arrived they took my papers and bought me.

I was taken to an apartment and locked in a room with bars on the windows.

I was ordered to have sex. I had eight to twelve 'clients' every day. I had to have sex in 'sick' ways.

Some men would hurt me, smash my head against the wall. I was kicked, severely beaten. I couldn't talk to anyone.

One meal a day, two to four hours for sleeping,

One day the police came and I was deported home, broken and scarred.

I have nightmares every night but I've told no one my story, not even my husband.

I feel lucky to be alive – most girls like me don't live to tell the story.

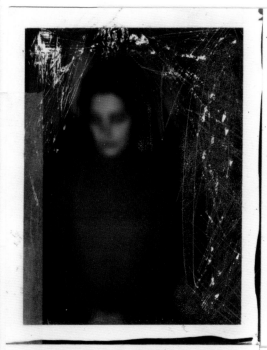

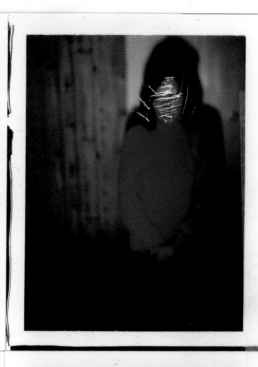

В 2006 році я прочитала рекламу в газеті „потрібні офіціанти в Німеччині"
Я прибула в Гановер, мене забрали в квартиру і я була закрита в кімнаті з решітками на вікнах.
Вони забрали мої документи

Мені наказали надавати СЕКС-ПОС-ЛУГИ, і коли я відмовлялася, мене жорстоко били.
Один раз на день їжа, 2-4 години сну, 8-12 „клієнтів" на день кожного дня.
Я змушена була займатися сексом із збоченцями.

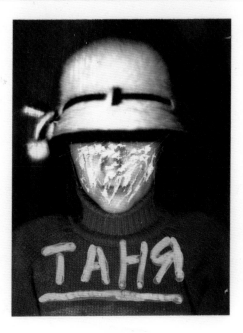

деякі чоловіки завдавали мені болю - кидали мене головою об стіну
Я НЕ МОГЛА НІ З КИМ ГОВОРИТИ.
Одного дня прийшли поліцейські і я була депортована назад додому.
Я ніколи не розказала моєї історії, навіть чоловікові.
Мене тривожать нічні кошмари одні і ті самі.
Я щаслива, що залишилася живою - не так як ті дівчата, які залишилися там.

↑
SMALLER?

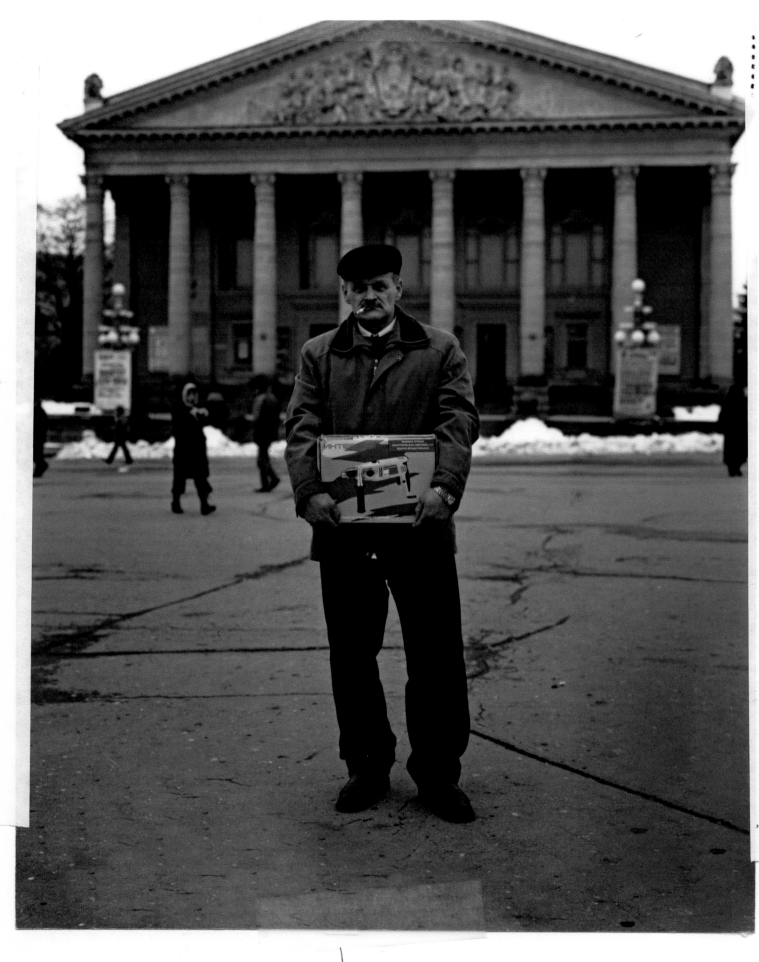

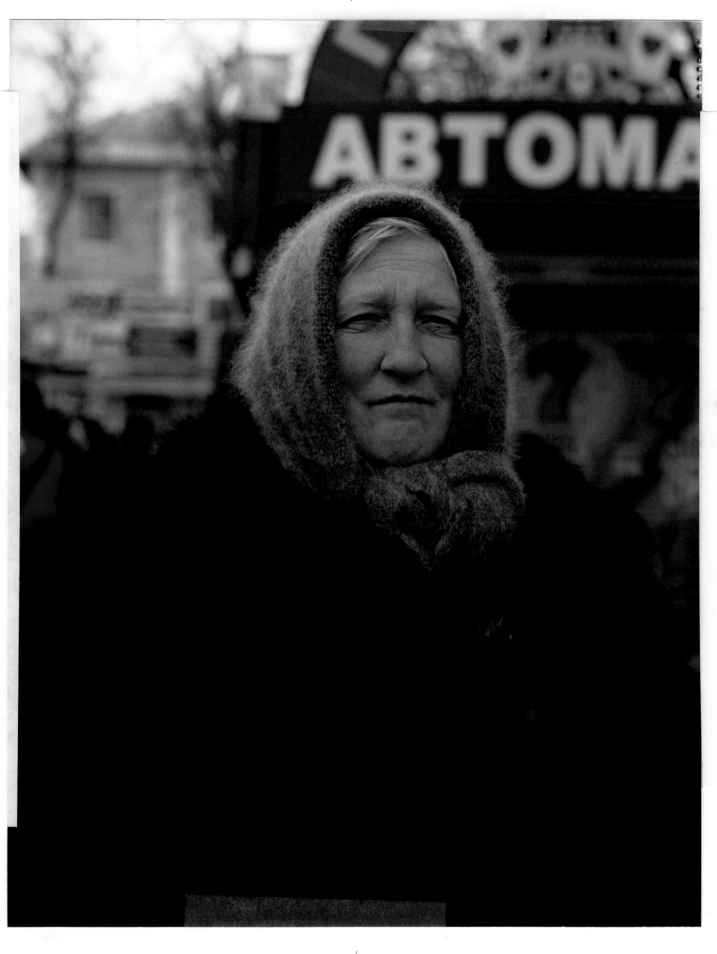

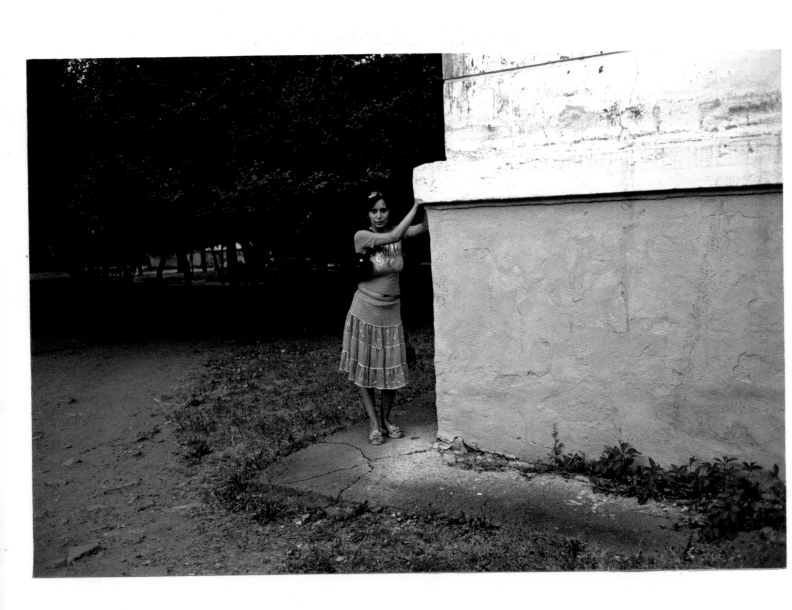

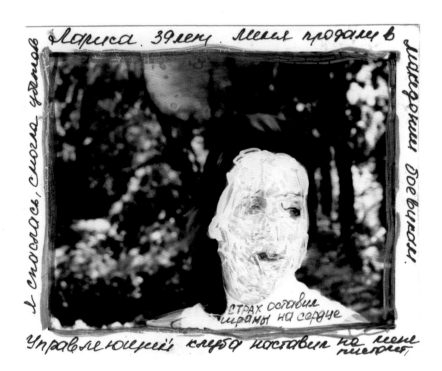

Лариса. 39 лет. меня продали в

шаверюнии боевикам.

я спаслась, скольа уятиов

страх оставил
шрамы на сердце

Управляющей клуба поставил на мене
пистолет

ДОПОМІЖНА ФОРМА ДЛЯ ІНТЕРВ'Ю

Місія МОМ Київ

Неурядова організація:	Донецька обласна Ліга ділових і професійних жінок
Контактна особа:	
Дата заповнення:	14.01.2005

Реєстрація
Індивідуальна ідентифікаційна інформація МОМ:

Ім'я:	Прізвище:	Громадянство:	Українське
Стать: (Ч/Ж) жін		Країна народження:	Україна
Дата народження: (дд-м) 19.01.1989		Місце народження:	Донецьк

1. ОСОБИСТА ІНФОРМАЦІЯ

1	Повне ім'я, по батькові, прізвище матері:	
2	Повне ім'я, по батькові, прізвище батька:	
3	Сімейний стан:	не одружена /
4	Чи має дітей?	ні
5	Кількість дітей:	
6	Псевдонім:	
7	Дівоче прізвище	
8	Батьки / опікуни:	
9	З ким проживав/проживала до виїзду з рідної країни:	Чоловіком чи дружиною / у сім'ї: з мамою, старшим братом і молодшою сестрою / у друзів / у рідних / сам чи сама / в установі / з партнером / інше / н.п.
10	Якщо "інше", прохання вказати:	
11	Адреса останнього місця проживання у рідній країні:	
12	Як жертва оцінює економічне становище своєї сім'ї?	малозабезпечена

2. ДОСВІД РОБОТИ ТА ОСВІТА

1	Чи має жертва будь-який попередній досвід роботи?	ТАК		
2	У країні походження?	ТАК		
3	Місце роботи:	кафе		
4	Посада:	Офіціант, бармен		
5	Професійна діяльність:	Домашня праця / секс-індустрія / інше		
6	Якщо "інше", прохання вказати конкретно:			
7	заробітна платня приблизно / заробітна платня на місяць у доларах США):	50		
8	Індивідуальна кваліфікація на поточний час:			
9	Сектор:			
10	Сфера індивідуальних інтересів:			
	Сектор:			
11	Поточний рівень освіти:			

6	Як жертва була визволена?	випустили		
7	Чи ставала ця особа жертвою торгівлі людьми раніше?		НІ	
8	Якщо "так", до якої країни цю особу вивозили раніше - прохання вказати конкретно:			

8. ПРИМІТКИ (ІСТОРІЯ ПОТЕРПІЛОГО):

Мій брат знайшов фірму, яка влаштовувала моряків на кораблі в Росії. Ми порадились і вирішили разом їхати. По друзях набрали грошей в борг, заплатили фірмі за працевлаштування, оформили всі документи. Їхали групою: 6 осіб з Маріуполю в Донецьк, звідти літаком в Москву і літаком на Сахалін. Зустрів представник фірми „Юг-Сервіс", Толік. Паспорти забрав. Два дні ми жили в готелі, чекали інших, теж українців. Потім Толік всіх привіз в порт на корабель „Первореченск". Поки льоду було багато, ми місяць – півтора в море не виходили, ремонтували корабель, перевіряли обладнання. Коли вийшли в море крабів ловити, почалась справжня робота. Працювали майже цілодобово: хвилин 15 на їжу, година-дві на сон, все! З ніг падали, але хворіти неможливо: лікаря все одно немає, та й з зарплатні вирахують. Ми тоді ще сподівались на зарплатню... Нам казали, що от–от вилов продадуть і тоді нам все виплатять. Але ми здавали вилови один за одним, а грошей не було. Спробували протестувати. Безглуздо: корабель не заходить в порти, втекти нема куди! Та й на березі, як нам казали, своя „криша", приб'ють, і не встигнеш пікнути... Отак і було: хто не працює – не дають їжі і води. А робота дуже важка: ніякого відпочинку протягом двох-трьох діб, потім кілька годин сну і знову вахта! Їжа теж спочатку нібито нормальна була, а потім так годували, аби ми тільки не повиздихали! Десь через два місяці наш корабель арештували прикордонники за відсутність дозволу на вилов крабів. Але представник фірми „Юг-Сервіс" (власник корабля) якось все влаштував, що прикордонники „не помітили" як ми скинули крабів за борт, а потім корабель звільнили за відсутністю будь-якого доказу. Тоді той представник фірми нас умовляв потерпіти ще місяць: мовляв, на хабар великі гроші довелось дати, тепер треба один раз наловити і продати крабів, а потім він нам всі борги по зарплатні віддасть. Але знову обдурив! Протестувати неможливо: їжі не дадуть. З корабля втекти неможливо: ми не заходили в порти. Все що виловили перевантажували на інше судно прямо в морі. За відмову працювати могли просто викинути за борт. За будь-яку провину – штрафи. Там були хлопці, що більше року на берег не сходили. А один так і зовсім – 4 роки в морі! Ми з братом вже капітанові говорили – не треба вже ніяких грошей, тільки відпусти!

Через 9 місяців нас з братом і ще вісім хлопців висадили на берег, тому що ми вже виснажені були, не могли нормально працювати, а вербувальники нове „м'ясо" привезли: нових рабів. Толік дав на дорогу по 300 доларів. Посміхаючись, обіцяв переслати на банківські рахунки всю зарплатню, що нам фірма винна. Досі шле... Можна було б його там побити, та він з охоронцями був.

Потім чули, що російська міліція корабель арештувала, власників фірми розшукує. А ми в Маріуполі надали свідчення в міліції про вербувальників...

9. ПОВЕРНЕННЯ

Маршрут повернення		
Країни	Дата, місяць, рік	Типи транспорту
Росія - Україна	**26.10.2005**	**літак**

1	Плани на майбутнє:	знайти роботу, закінчити навчання, покарати вербувальників
2	Де та з ким вона хоче жити:	Членами сім'ї
3	Що вона хоче робити?	Вчитися, знайти нову роботу
4	Інше:	
5	Чи змінилися стосунки усередині її сім'ї після її повернення?	ні
6	Яку допомогу вона потребує?	фінансова, юридична, оплата навчання
7	Чи бажає вона співпрацювати з правоохоронними органами?	ТАК

10. ОЦІНКА РИЗИКУ, ЗРОБЛЕНА МІСІЄЮ, ЯКА ПЕРЕДАЄ СПРАВУ

10.1. ФАКТОРИ РИЗИКУ, ПОВ'ЯЗАНІ З ЖЕРТВОЮ

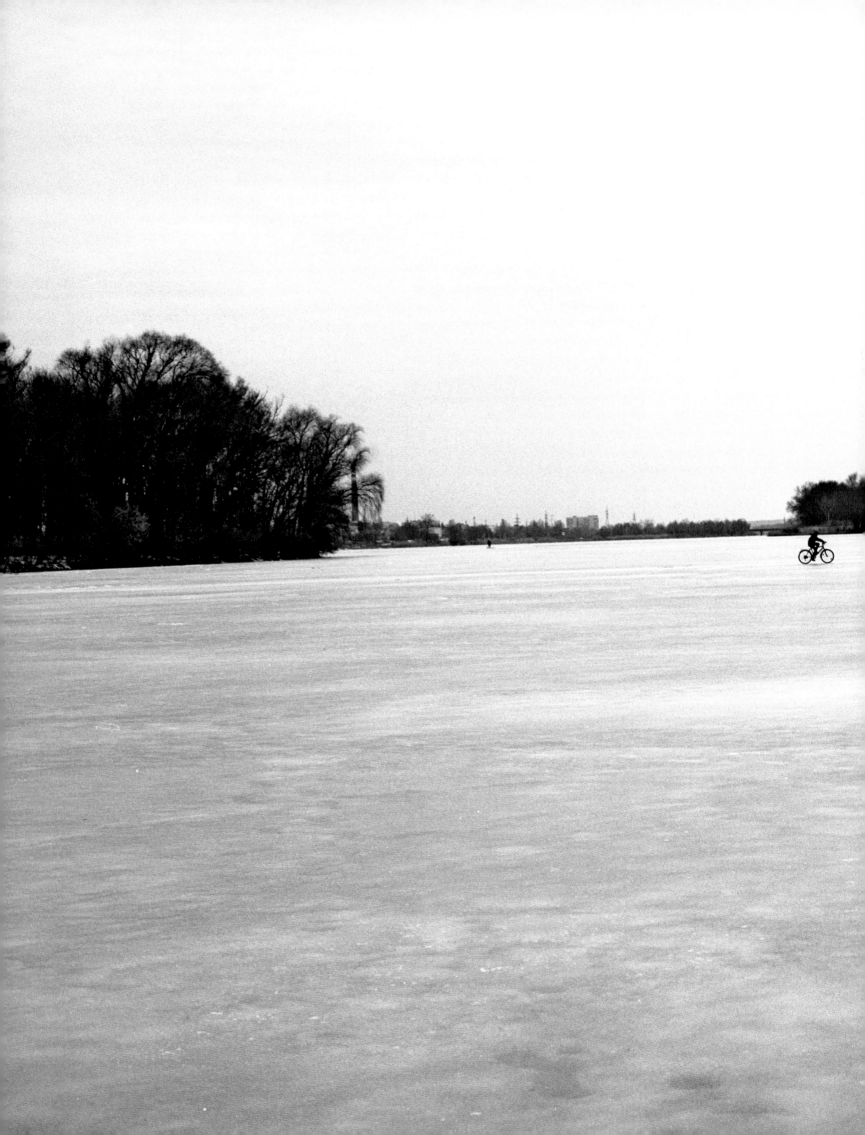

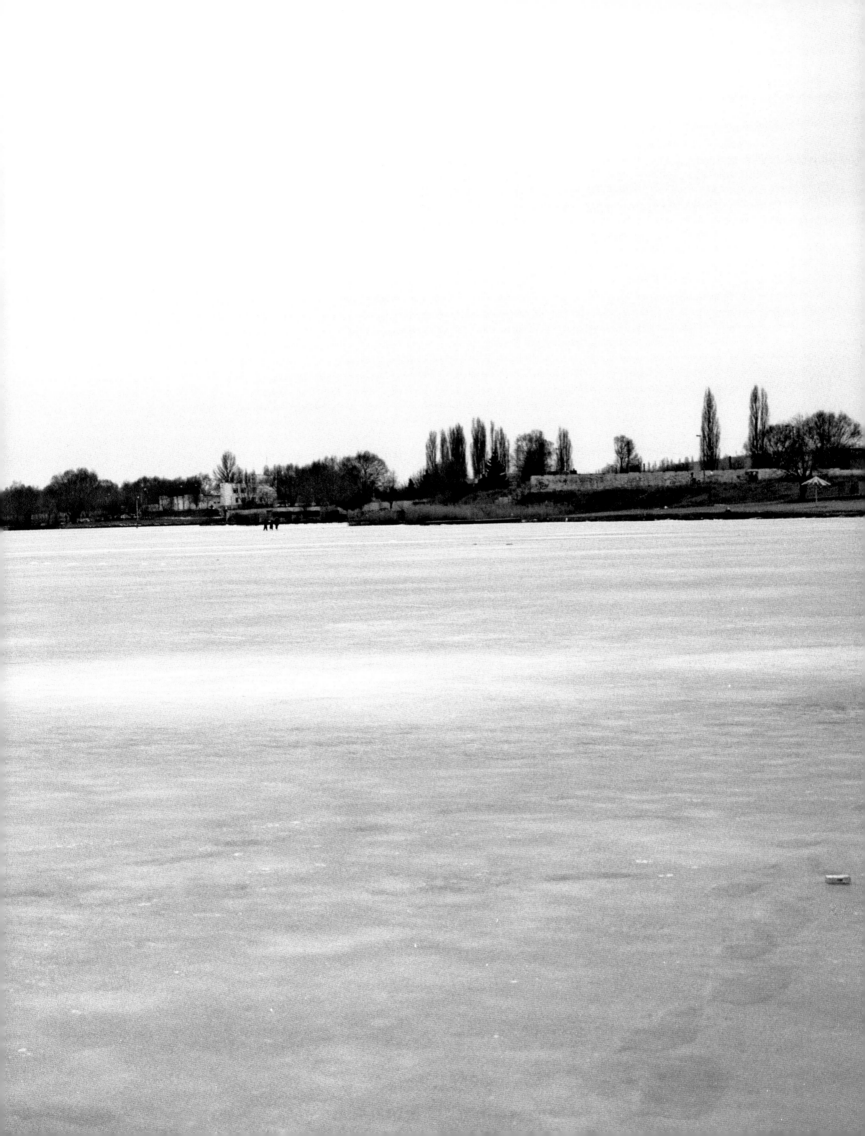

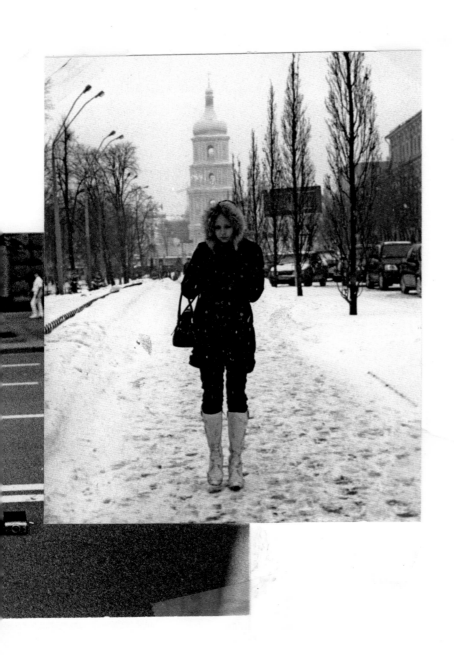

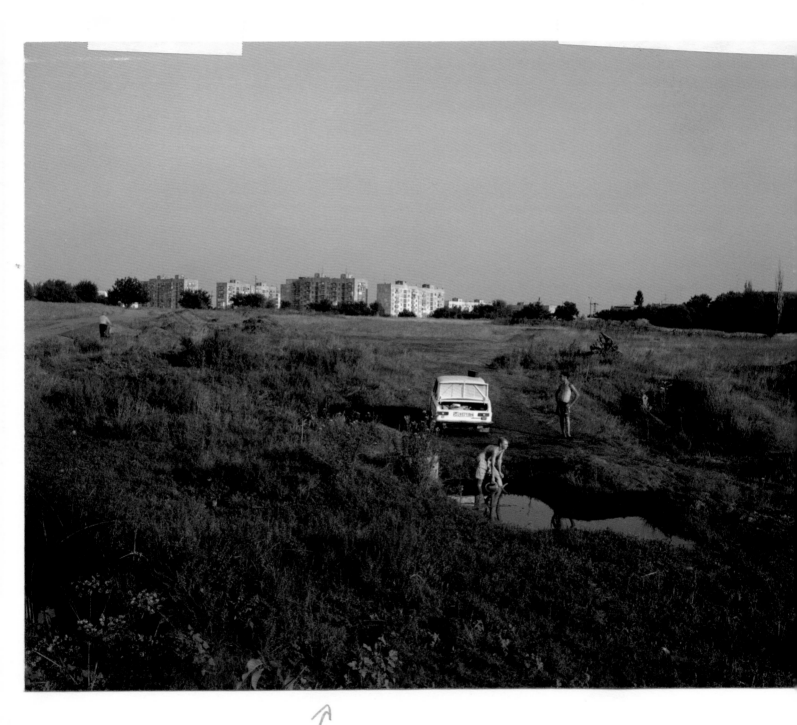

MORE GOLDEN LIGHT

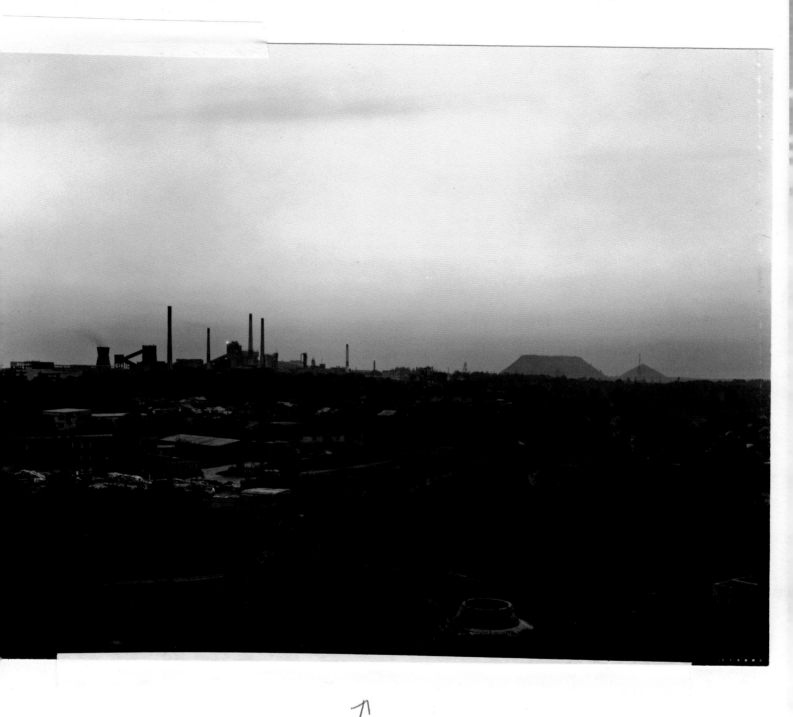

DARKER

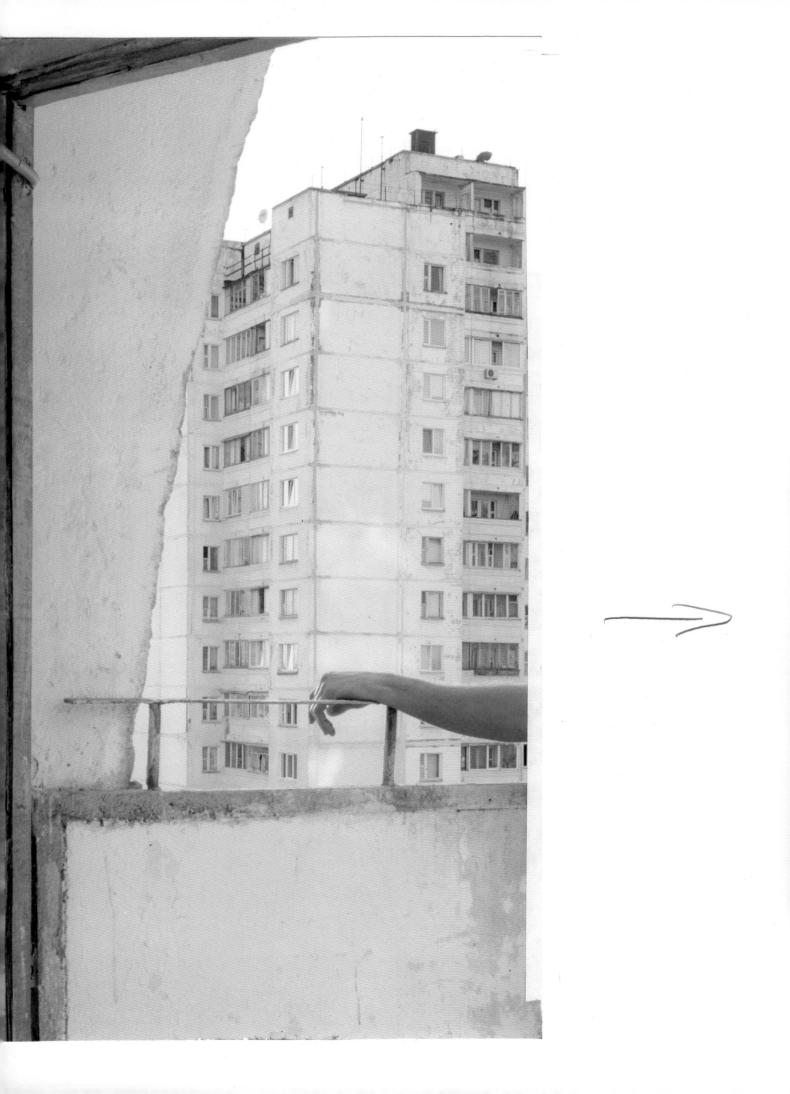

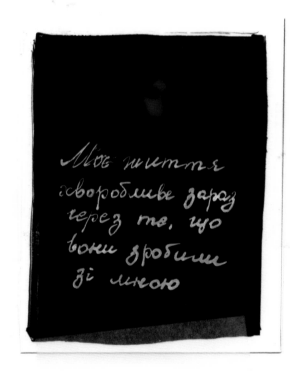

Моє життя
хворобливе зараз
через те, що
вони зробили
зі мною

MY LIFE IS

SICK BECASE

OF WHAT

THEY DID

TO ME

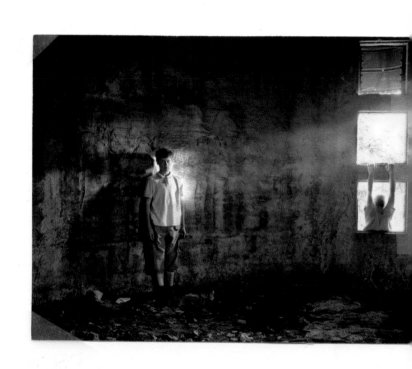

too
DARK

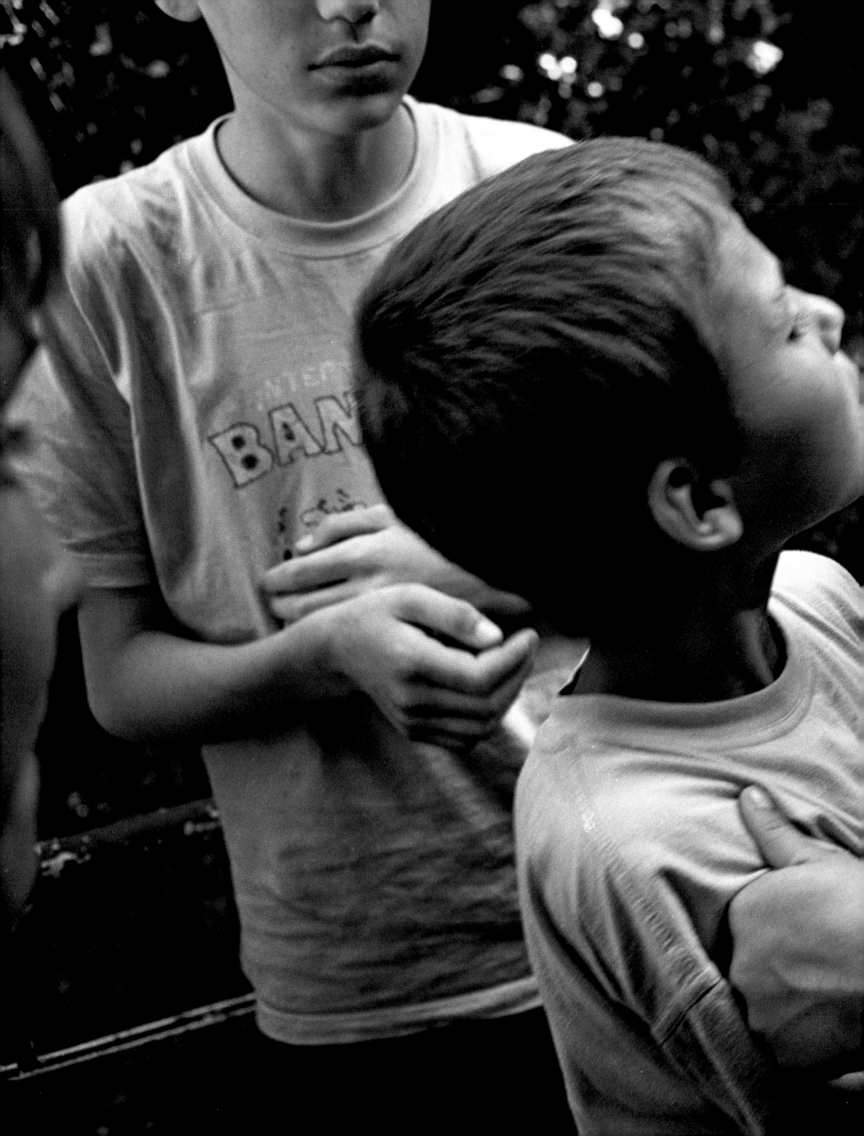

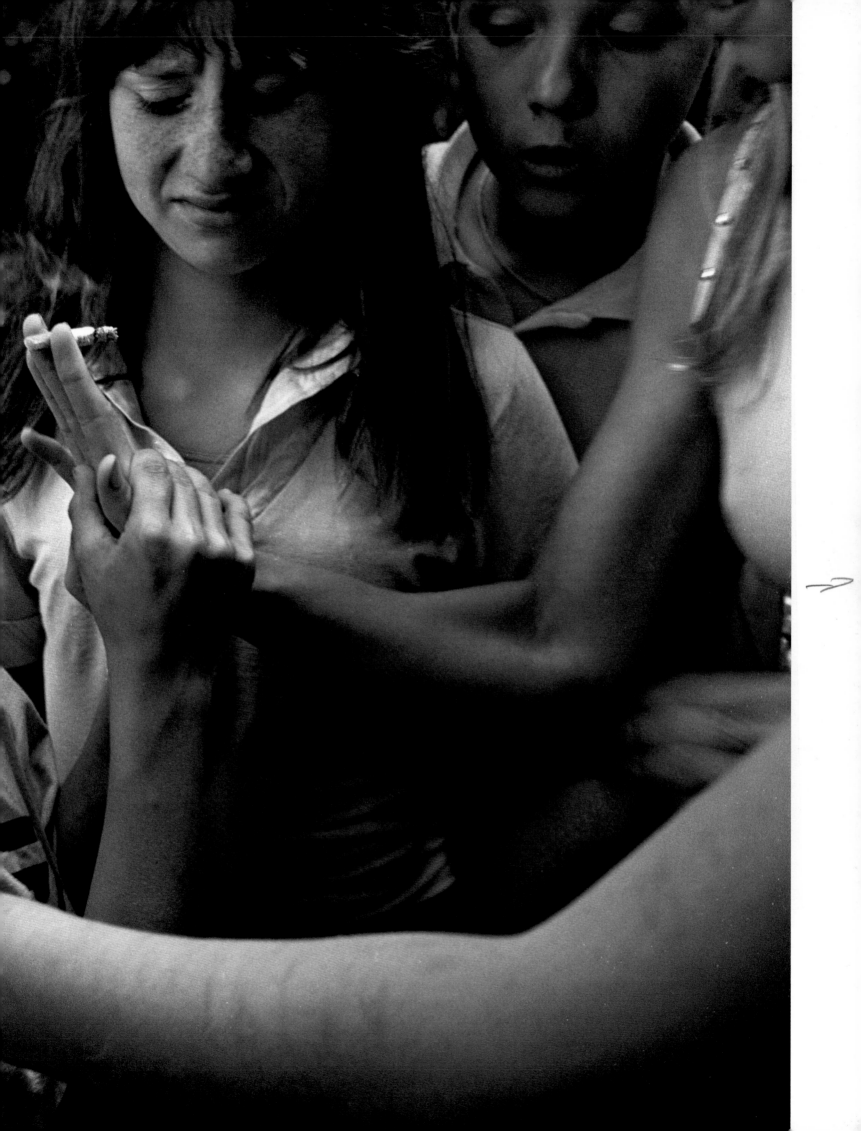

Anya

July 1, 2006, and the wrong side of luck

Some sad things that have happened to me
(or why I don't care if I die)

I have been on the street for ten years since I was seven.

My mother was a prostitute because she had no money. She was killed
by my alcoholic, unemployed father. He is in prison.

I have two brothers, one is twenty-three and the other is eighteen years
old. My twenty-three-year old brother drinks and works in a rehab
center for drug addicts. He lives with my grandmother and uncle in a
small village. No contact with him.

4.07 06.

Все вещи што самной случилась.

(Изаетава я не боюсь смерти)

Живу на улице уже 10 лет кагда мне
била 7 лет мая мама била праститут-
кай. патамушта у нас небила денег.
Мой атец алкагаик (и без работы) и он убил
маю маму. И щас арестован.

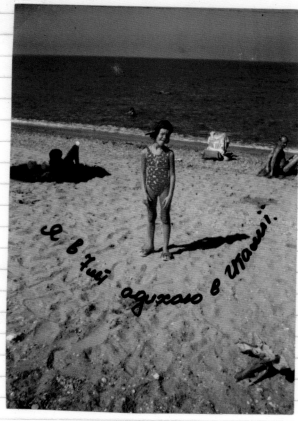

Я в 7 лет
адыхаю в итали!

Имею два брата 18 лет 23 лет. мой брат
каторому 23. Упатребляет алкаголь. и работает водках.

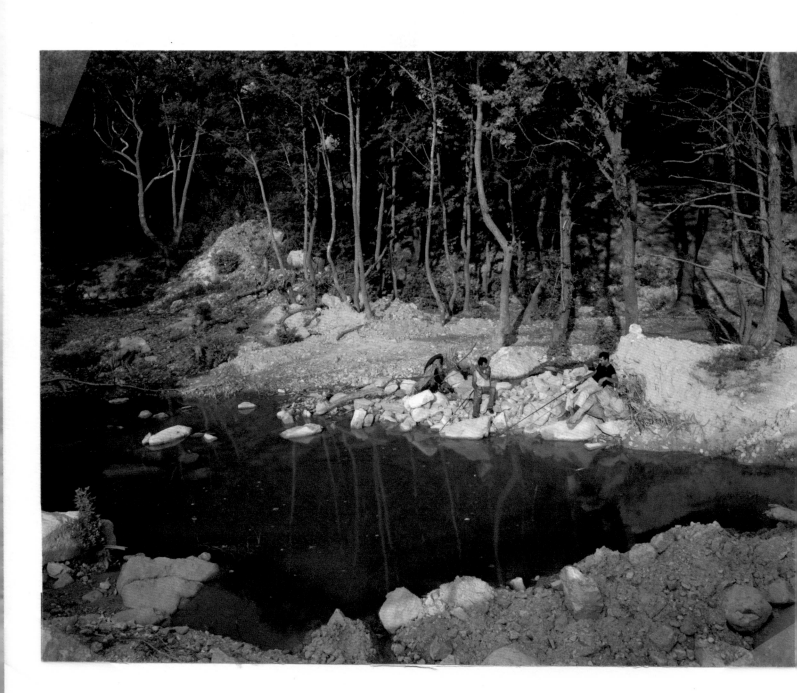

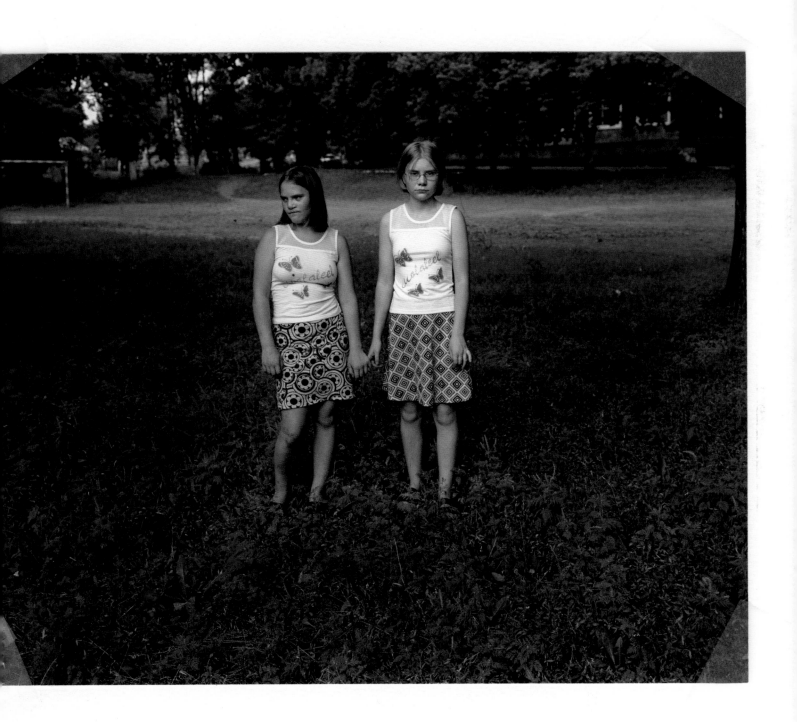

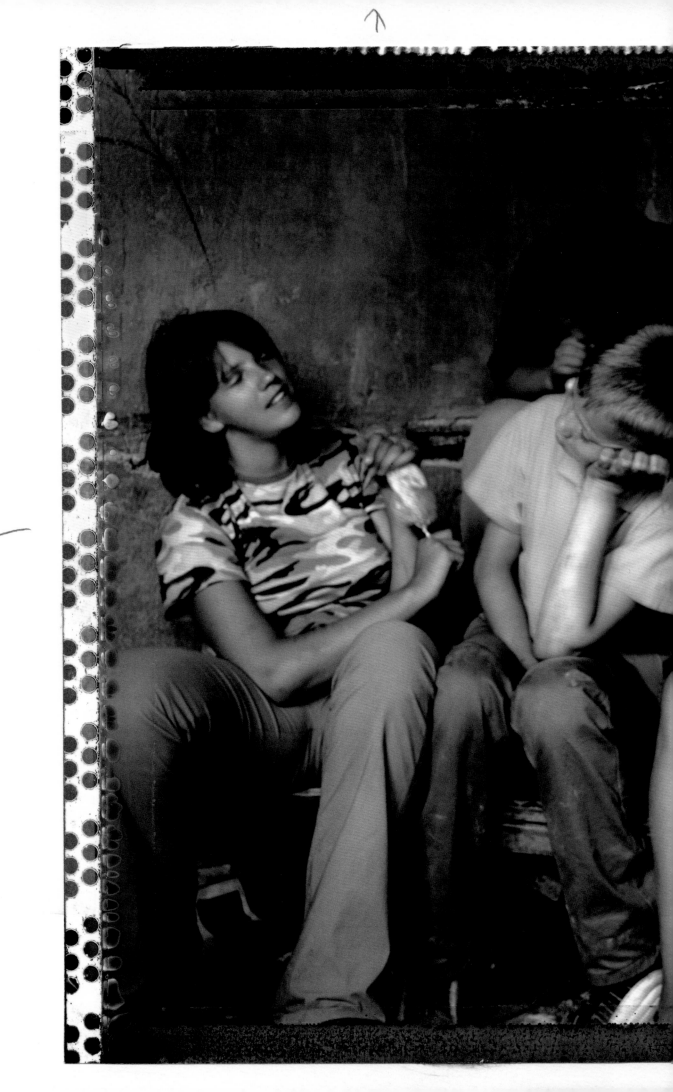

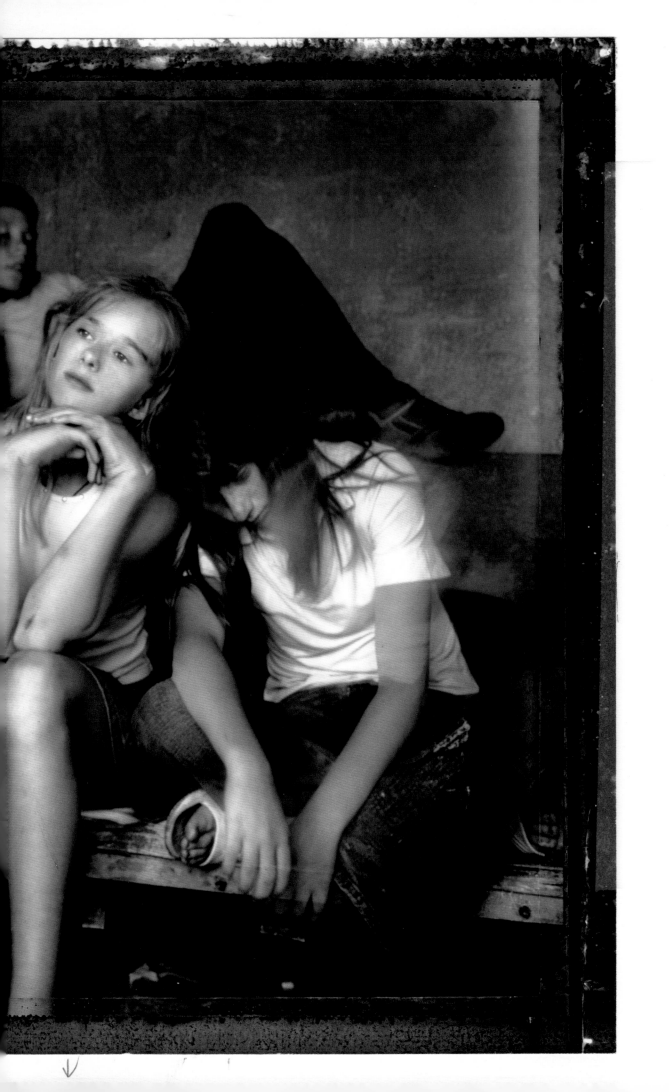

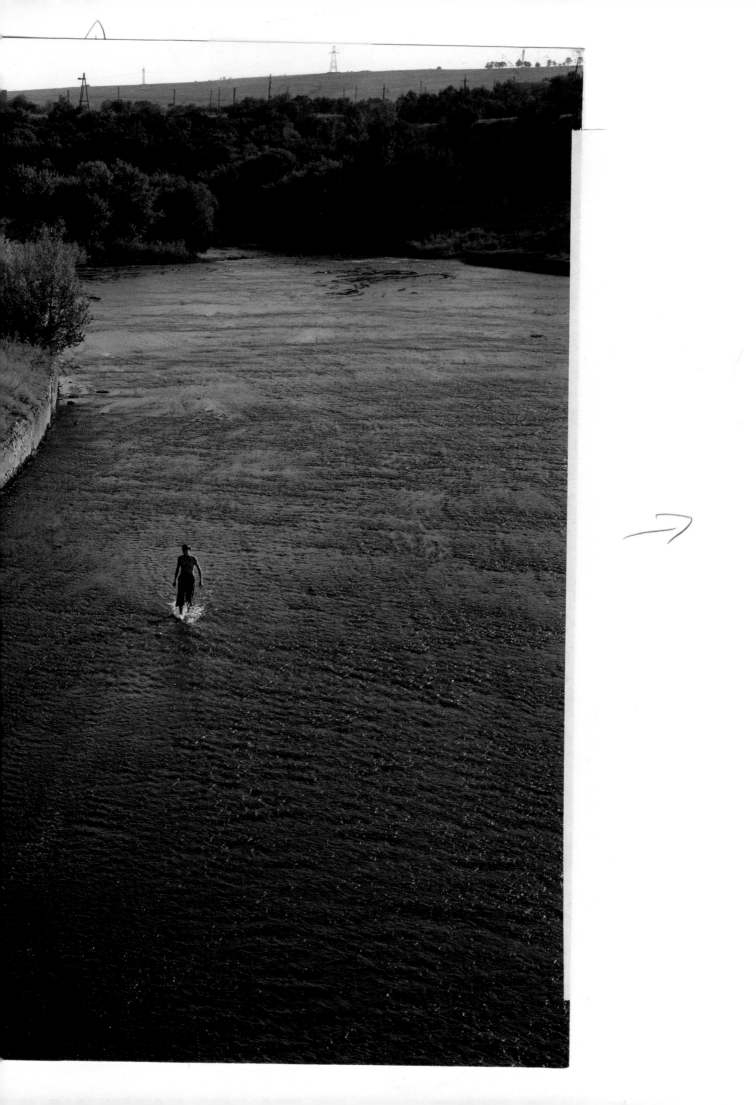

name is Klavdiya

children didn't want to be slaves, but their bad father stole them
ay without my permission to Poland where they were forced to beg
have sex everyday. … I would like to see my daughters happy,
 instead there are the tears of grief and the scars of a bad life.

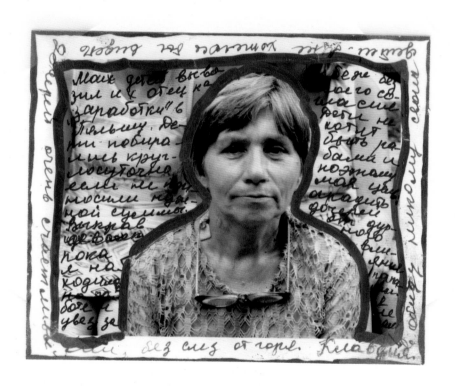

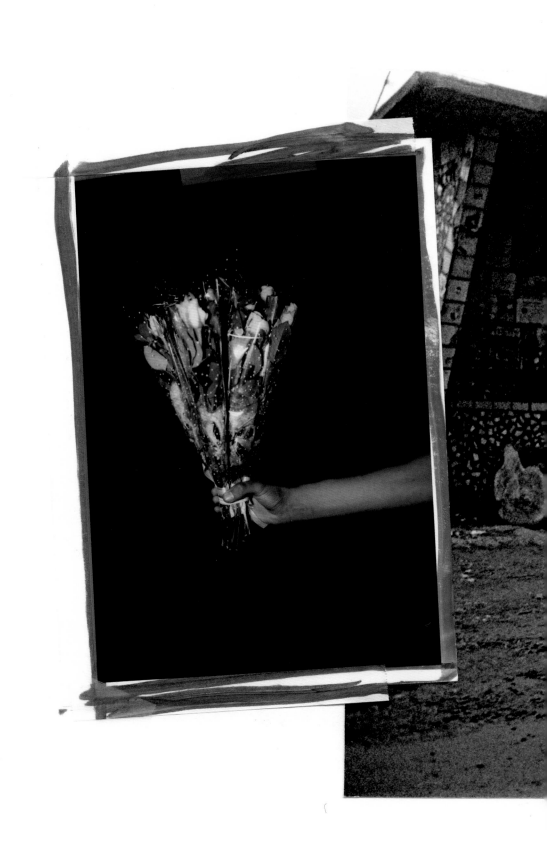

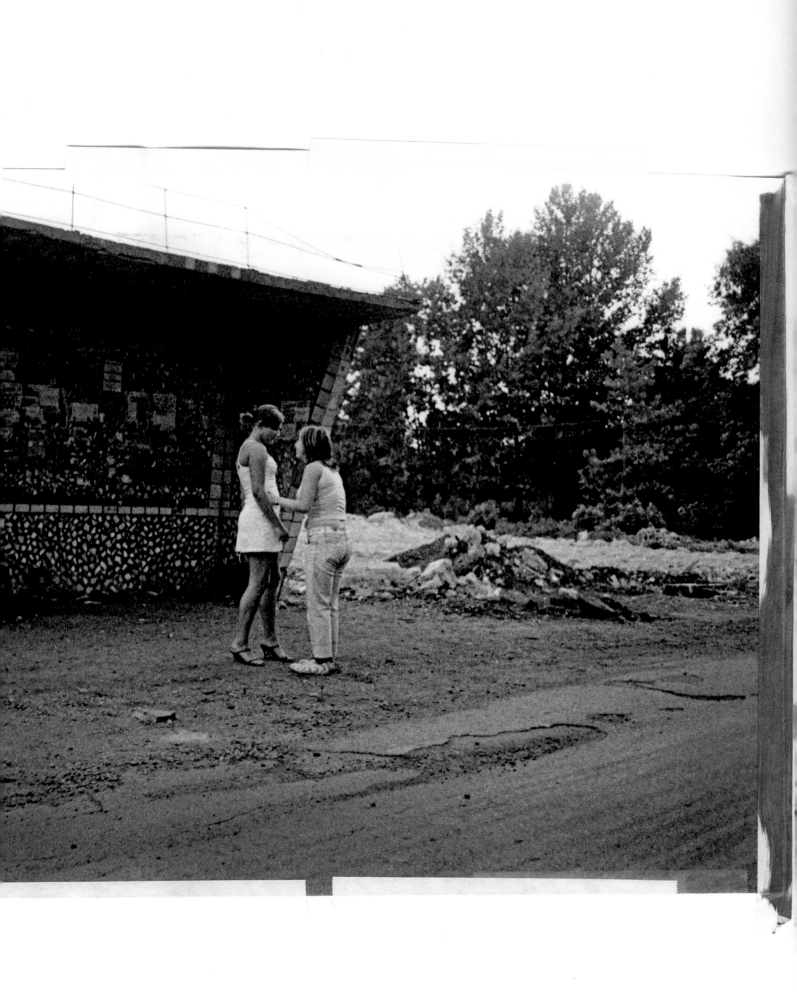

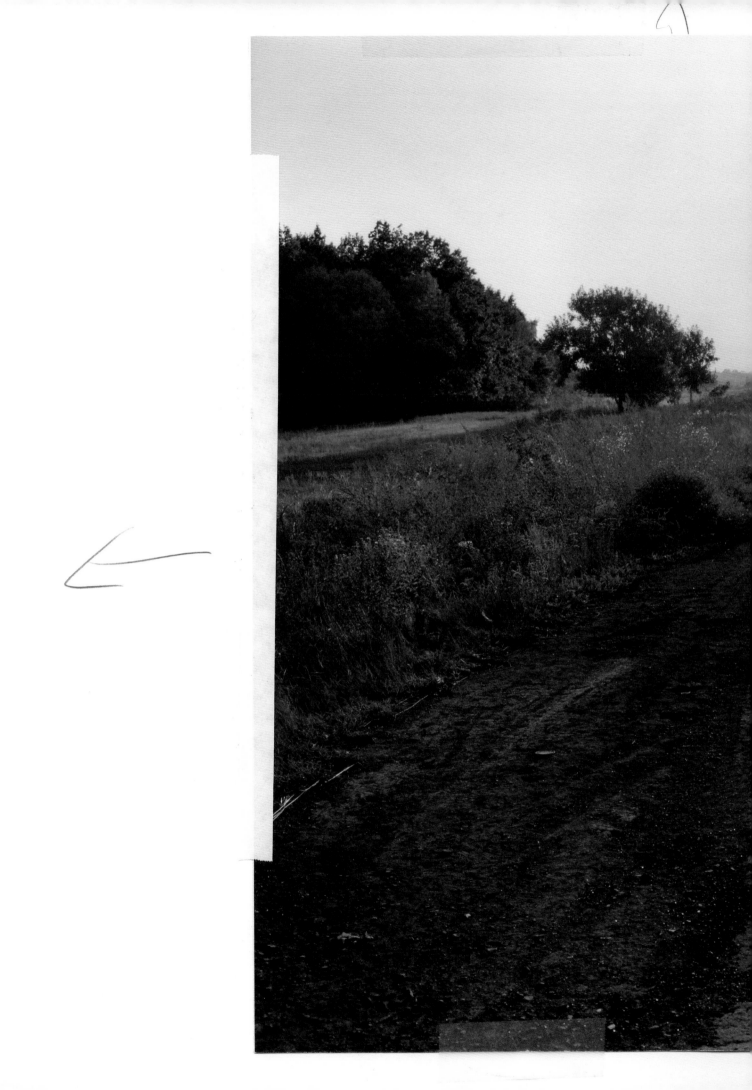

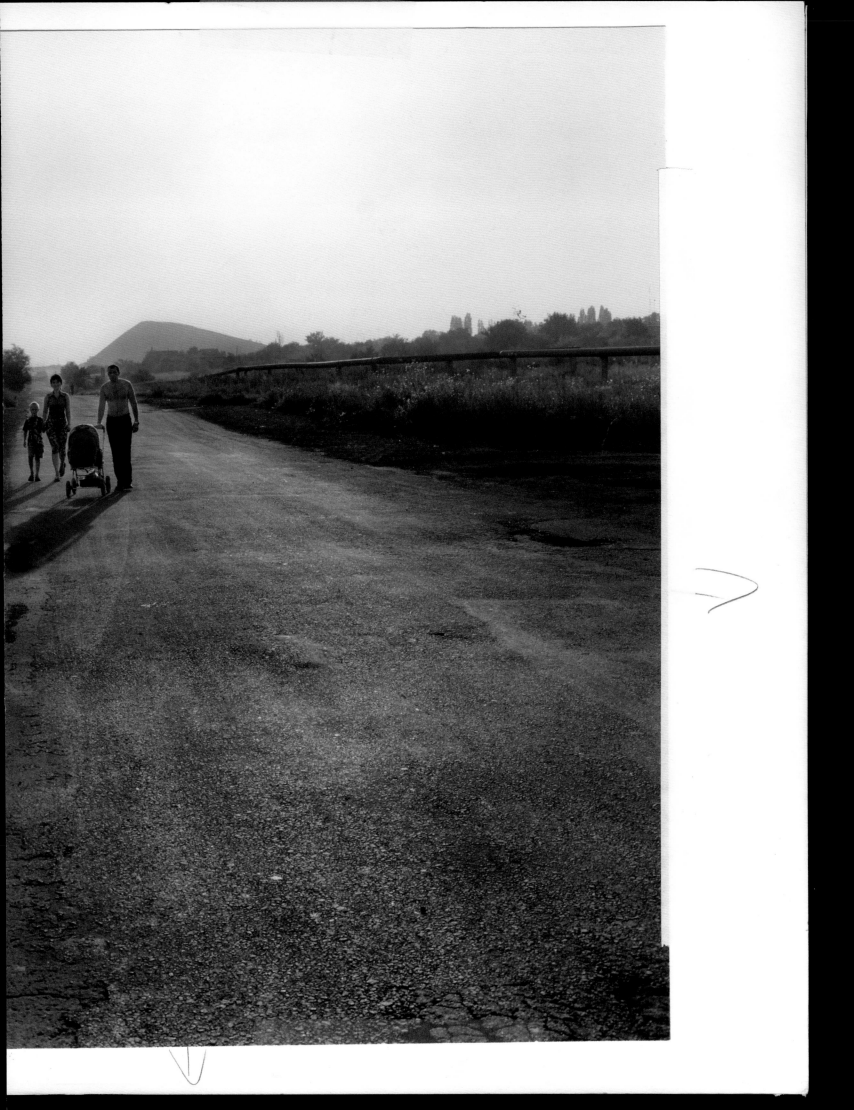

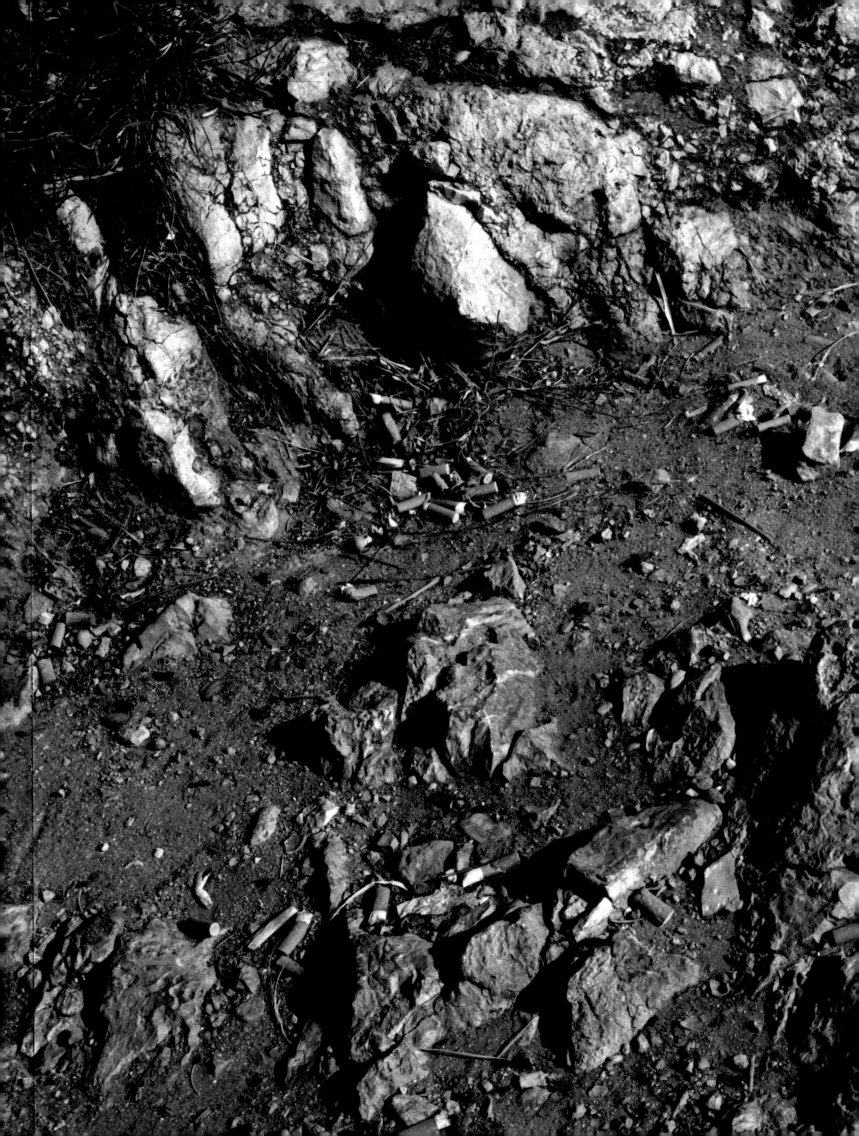

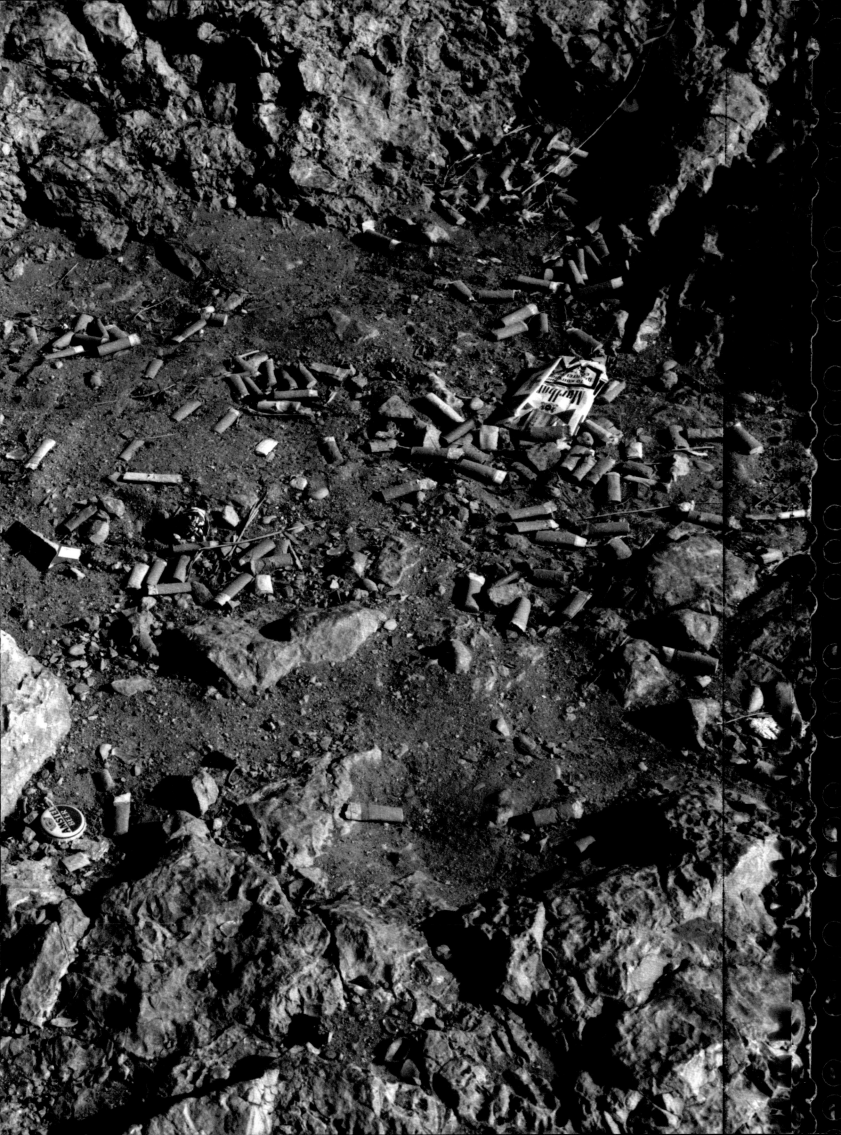

The portfolio on the preceding pages presents a work-in-progress by artist Jim Goldberg. This work was created in part with help from the Aftermath grant, and is in a sense a prologue to a longer, ongoing body of work, The New Europeans (working title). As Goldberg describes his project, 'This work tells of the insurmountable difficulties refugees and migrants face, of their dreams for freedom and their indomitable will to survive. … This immigrant population includes refugees, asylum seekers and trafficked peoples, lives in compromised living situations, often on the margins of society. This is a body of photographic work that proposes to document these diverse peoples, who come from such places as Iraq, Somalia, Congo, Ukraine, Albania, Russia, Poland, Nigeria, Eritrea, Ethiopia, Egypt, Bangladesh, Pakistan, China, the Philippines, Sudan, Kenya, Kurdistan, Afghanistan, Bulgaria, Palestine, and Moldavia. … These peoples are the aftermath of European and global problems, often leaving war torn and economically devastated countries, AIDS-ravaged communities or totalitarian regimes, in search of a safe home. Despite the harsh realities they endure, theirs is a story of hope and heroism.'

This project started as a Magnum commission for the 2004 summer Greek Olympiad. In Greece, Goldberg found a community of immigrants seeking asylum, who were more or less 'invisible' and marginalized, despite the country's dependence on them for skills and services. In doing so, he became interested in tracing the path by which many of these immigrants had found their way to Greece. Goldberg portrays the evolution of the project as having intuitively moved toward 'symbolically mapping a trail – where people come from, but also why they want to leave.' He describes his process, for the past five years, as a meld of 'photographing and collecting oral histories – handwritings on Polaroids in different languages, video recordings, written text and ephemera. I have photographed immigrants, refugees and trafficked peoples in Athens, the Greek Lavrio refugee camps, the border crossings around Albania, Bulgaria and Turkey, the agricultural farmlands throughout Greece, the northern Muslim enclaves of Xanthi, extreme poverty in India and Bangladesh, and Ukrainian migration as a result of trafficking.'

These peoples are the aftermath of European and global problems, often leaving war torn and economically devastated countries, AIDS-ravaged communities or totalitarian regimes, in search of a safe home.

The maquette shown here focuses primarily on the Ukrainian portion of the project. Since the breakup of the Soviet Union and the collapse of the Ukrainian coal industry, there exists an ever-increasing number of unemployed people. The amount of trafficked women, men, children and babies in Ukraine has grown exponentially. The portfolio offers a glimpse of the artist's working process. It was produced for the specific purpose of this publication, but also as a way of working through the ideas and the shape of the work to come. Created with input from Goldberg's frequent collaborator Philip Brookman, this is in essence a sketch of what will become the first chapter, called 'Home', of the larger series. Upon completion, the entire series will comprise four sections: Home, Victory, Getting by and Asylum, and will be published to accompany an exhibition of the work at the Fondation Henri Cartier-Bresson, Paris, in spring 2009.

MORIE, PRINCE OF THE DEAD

A DAY OF MASSACRE.
OVER A THOUSAND VICTIMS.
A SINGLE SURVIVOR, SPARED BY CRUELTY.

Photos: Wolf Böwig
Text: Pedro Rosa Mendes

In the insanity of killing, the ultimate refinement of horror can be to refrain from killing. Morie was the victim of such an act of cruelty. His entire village was killed to the last man, and he, he alone, was left alive. 'They showed me the dead people and made me chief of the village, threatening to kill me if I ever crossed their path again.' Morie's mother, before the attack, had put her little prince to sleep. In mid-slaughter, gunshots woke the boy to the nightmare of living. 'When the rebels found me inside the house, they grabbed my hand and took me to the village, till I identified my father.' There lay his father, in the middle of the apocalypse, still identifiable, 'with his belly open and his throat cut.'

Morie was five the day they interrupted his life. Today, 'ten, almost eleven,' according to the uncle who teaches him the Koran in a modest madrassa in Pujehun, in the southern part of Sierra Leone. Maybe he's still only ten, maybe he's already twelve. Morie was born on Bonthe Island, in 1992 or 1993, and the attack on Bendu Malen, his village, in a remote part of that remote district, occurred in 1997. A five-year-old child doesn't know how long ago it was or how long it lasted; he remembers only that the Bendu Malen massacre took place, he says, 'at the beginning of the rains.'

The facts as known: a group of *kamajors*, Civil Defense units (CDF), expelled from Bendu Malen, rebels of the United Revolutionary Front (RUF). The next day, the rebels, bypassing the *kamajors*, returned and surrounded the village. Vengeance followed. Between morning and evening, the rebels methodically decimated the population. Perhaps as many as twelve hundred victims, according to the Truth and Reconciliation Commission (TRC) that visited the location last month. To date, no one has been accused of the massacre. One version points to the responsibility of soldiers from the SLA, the regular Leonese army, which at different times and in different regions was allied with RUF rebels.

NO LIVING THING

The orgy obeyed the criterion of No Living Thing, the code name for the brutal RUF assault on the country's capital, Freetown, on January 6, 1999. Its meaning: death was unleashed on men, women, and children and anything else that moved. Morie remembers this absurd detail of the massacre: 'In the middle of the people, chickens, dogs, goats, all dead…'

In Sierra Leone the rains are a short, rotten season. A time of low skies and clouds the color of tin. In mid-June the water descends with a mechanical sound. It superimposes itself on conversations and sleep, turning earth into mud and rusting zinc, dirtying the rivers on their way to the sea, reducing the horizon to arm's length, limiting gestures and movement, eating away at one's mood, accentuating the poverty. And this is just the beginning: in August, at any moment, the oppressive 'seven-day rain' can begin.

'As the massacre was in the rainy season, many bodies were unrecognizable when, some time later, we arrived in Bendu Malen,' Jiba Soko relates. 'Some were beaten to death, others had their throats cut, some were shot, others were killed with their hands tied.' The old man stretches out his thin arms as his gaze surveys a palisade of sharpened stakes that form a circle in one corner of the village. 'I was the first to enter here after the attack,' from another part of the district, 'over thirty kilometers away. There were corpses

Whenever
we dig,
whether
to build
a house
or farm
the land,
we find
mortal
remains...

everywhere and the houses were destroyed.' In Dandabu, 'where I was in the habit of sleeping,' Jiba Soko asked his brothers and friends for help to 'clean up' Bendu Malen.

'Here, in the middle of these stakes, were about 150 bodies,' the old man explains. 'Shall we dig?' It isn't necessary. 'There were more than twenty of us, and it took over a week to clear away the corpses. During that week we always left the pit open.' At the opposite entrance to Bendu Malen, in the shade of enormous trees, is another 'pit,' where Jiba Soko's group buried 275 bodies. 'Afterwards, we finally brought more remains, as we would find them.' The task is still not finished. It goes on intermittently.

Who were the victims? Jiba Soko knew some of them, like Morie's father, Bockarie Manssaré, the imam of Bendu Malen. Other people approach Jiba Soko and the common grave, offering additional names against the anonymity of the tombstone: 'Tiange Lahai'; 'Kefa Morana, Jussu Morana, Suleyman Morana, Mariama Morana'; 'Massa Cissé'; 'Momo Bendu'; 'write there: Hawa Siaka, Lucy Lansana, Mariama Soaré'; 'Uata Bockarye'; 'Baby Cenci'; 'Kadi Cenessi'...

'It was raining. I drank water.'

Morie, without raising his eyes, tells how he wandered for two days through the horror, unable to decide what to do. 'It was raining. I drank water.' That's all. He remembered, finally, taking the road to the vegetable garden where the family worked. 'I thought about finding my mother,' since she wasn't among the cadavers. On the road, Morie was discovered by a group of *kamajors*. One of those 'hunters,' named Mohamed, adopted the boy and sent him to a Koran school in another district.

Morie's mother was one of the few to escape from Bendu Malen before the village was surrounded. Only much later did she learn that her son was also alive. She searched for him, going from village to village, until she found him – after eighteen months. For the boy, it was not an entirely happy event.

For five years Morie has been the object of a dispute between his mother, his adoptive father, and two Islamic teachers, who use and somewhat abuse the student (the *madari* are as poor as the small *talib* who attend them, so all work in the field to pay for their education). Currently, Morie lives in Pujehun with one of the teachers, his uncle Alpha Mansaray (his father's brother), who is teaching him the rudiments of Arabic. This month, he enters the official school of the Catholic mission in the district.

Bendu Malen was razed a second time, but new men – including relatives of those who died – arrived to inhabit the same ground. It is a strange conjunction of the living and the dead. The entire village is, literally, a common grave, as Jiba Soko recognizes. 'Whenever we dug, whether to build a house or farm the land, we find mortal remains, bones, clothes, on all sides… We gathered the bones and are going to place them in one of the gravesites.' It is a frequent gesture.

'Over there, in that swamp, there's a common grave. Fifty bodies,' says the *soba* of Sahn Malen, Moyneh Moictyah. 'There, beyond the bridge, there's

another. There were sixty young people of Sahn Malen, all of them under twenty. They ordered us to open the pit before they killed them… Further on, at that cross, there's another collective gravesite…' En route to Bendu Malen, the road seems empty. On the way back, with Moictyah as guide, the crossing is infernal: ghosts in no-man's-land. 'There, next to the tree, they also buried people. "They" buried where the victims fell. Do you want to stop?' No.

GRAVES TO EXHUME

The graves of Bendu Malen, like all those that dot the forests and swamps of Pujehun, on the Liberian border, were never exhumed. At the height of the conflict, 'there were eighty-five RUF camps in this region,' according to the priest John Garrick, of the Catholic mission in Pujehun. 'Each camp had at least one common grave.' The peace process in Sierra Leone, which put the TRC mechanism in place, did not include forensic analysis and funeral ceremonies. 'Its point of departure was that the Leonese don't need to bury their dead. That's a lie. They do need to,' comments John Caulker, coordinator of the civic organizations that make up the Work Group of the TRC.

Mohamed Soko, the chief – the real one – of Bendu Malen, confirms that mourning is a luxury, one postponed sine die: 'What we are asking is support for religious ceremonies. By ourselves, we can't hold them with dignity. The victims have found no rest.' Neither, we might add, have the living.

In the common grave in the clearing, a few meters from the street that runs through the village, half a dozen skulls were left atop the small mound of earth that covers the other 250. 'Children are not allowed here.' The skulls are green, covered with a thin film of moss. Life grows on them, coating the ivory of the dead with a silent, delicate vegetal force – like all in the village-cemetery of Bendu Malen.

The TRC officials would like to transform little Morie's village into a memorial of the Sierra Leone civil war, something like the style (sometimes macabre but undeniably effective) of the memorials of the Rwandan genocide. For now, the deliverance of the dead takes place in simpler fashion, the most human of all: in the memory of the living. The new inhabitants of Bendu Malen know that names have the power to transform a common grave into a place of intimacy – an inhabited place. These names, uttered in the fetid air of the clearing, against forgetting and against timidity, seem to overcome the silence of the green skulls. 'Mamen Soko,' 'Lahai Yorgboh,' 'Braima Caulker,' 'Sina Mahe,' 'Gassumu Kandó,' 'Morie Massalé,' 'Foday Cassó,

Braima Lamine, Lamine Conowy,' 'Massah Kokima,' 'Mamie Kone'… Far away from there, Morie seldom speaks. Unless he's asked, he says nothing, about anything. Around him, on the veranda of the madrassa, among the chickens and manioc drying racks, the other children dash about, shout, tease, run away. He concentrates, with all his being, on his hands: he rubs one hand against the other, as if molding clay, or bread, or dreams. To us, the dream is invisible. To Morie, it seems very real. A new world that is his alone.

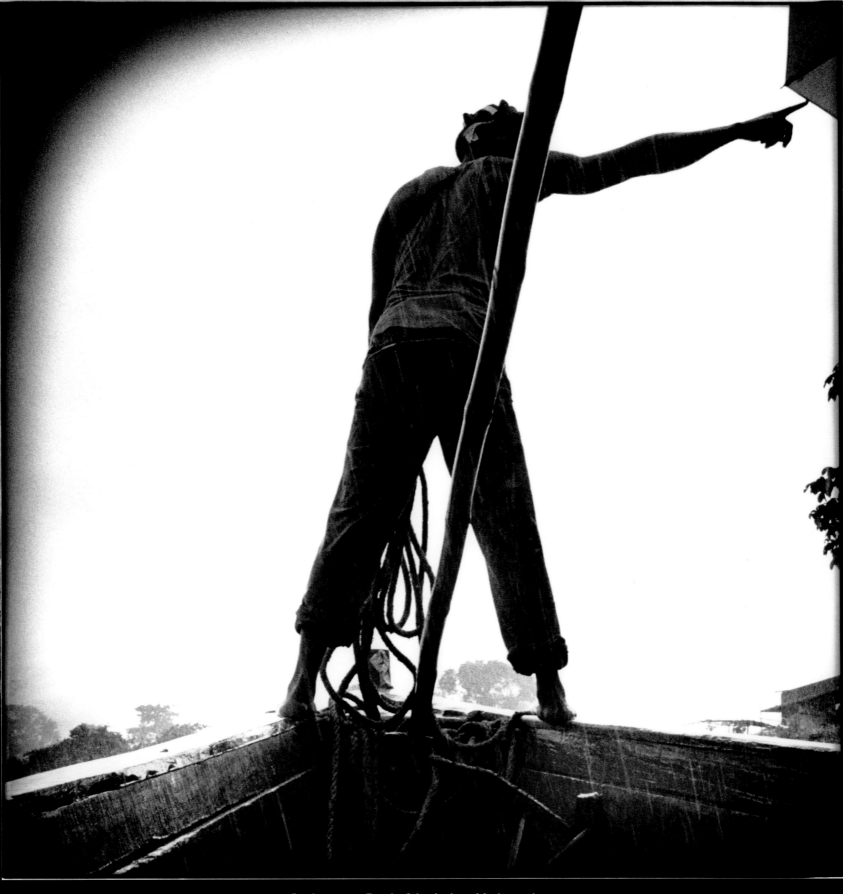

On the way to Bonthe Island where Morie was born.

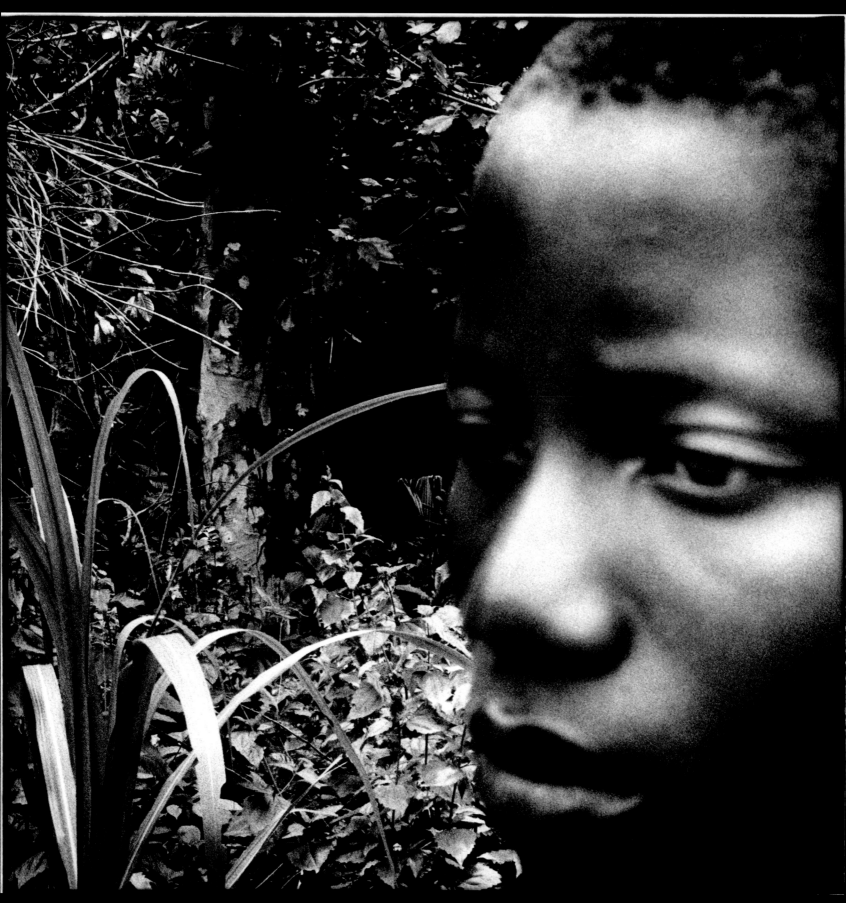

Morie in Bendu Malen: Here I found my father ten years ago...

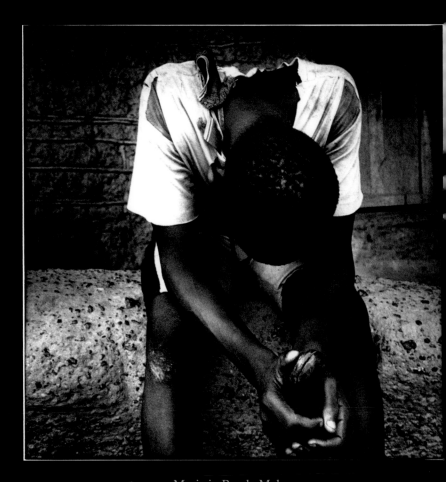

Morie in Bendu Malen

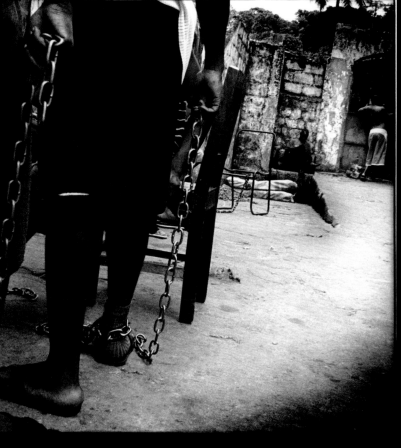
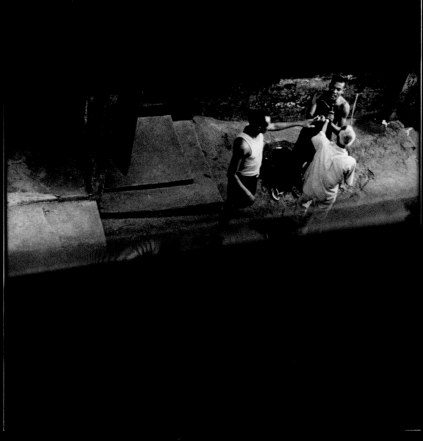

City of Rest, a rehabilitation center for traumatised youngsters, war veterans and drug addicts

Bonthe Island

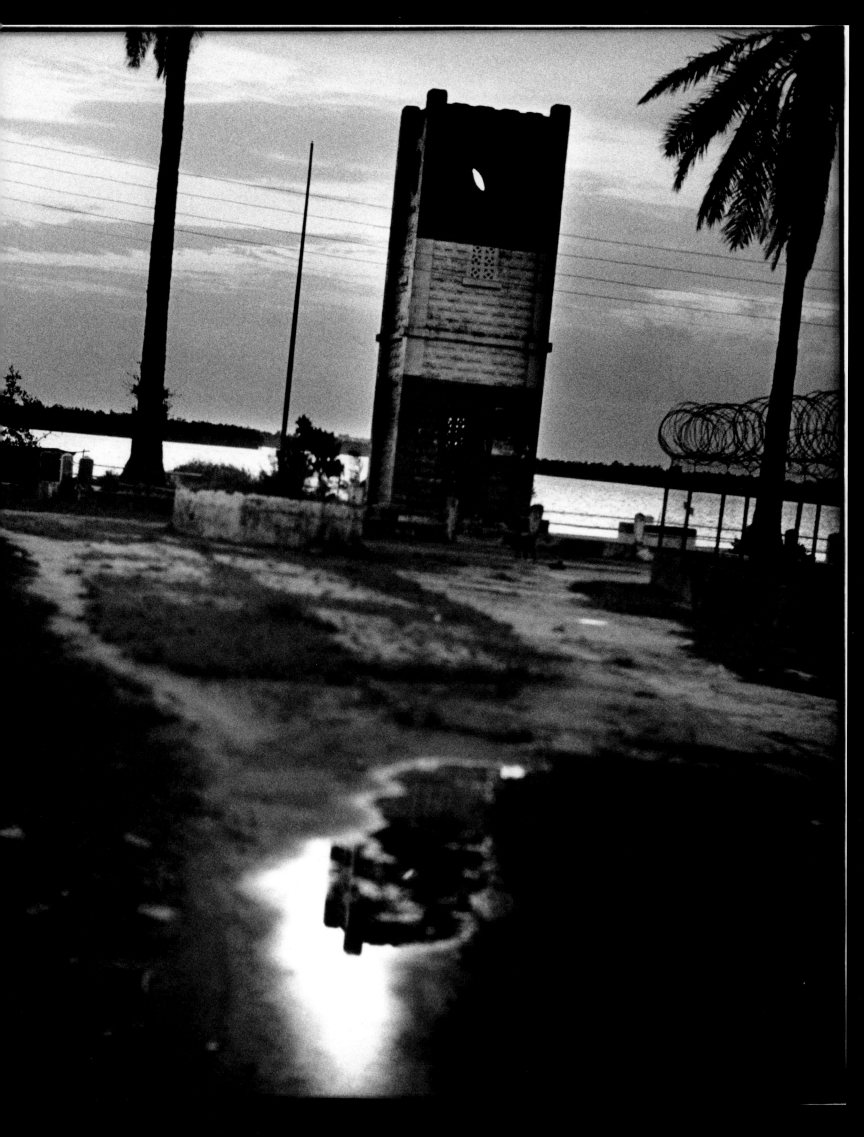

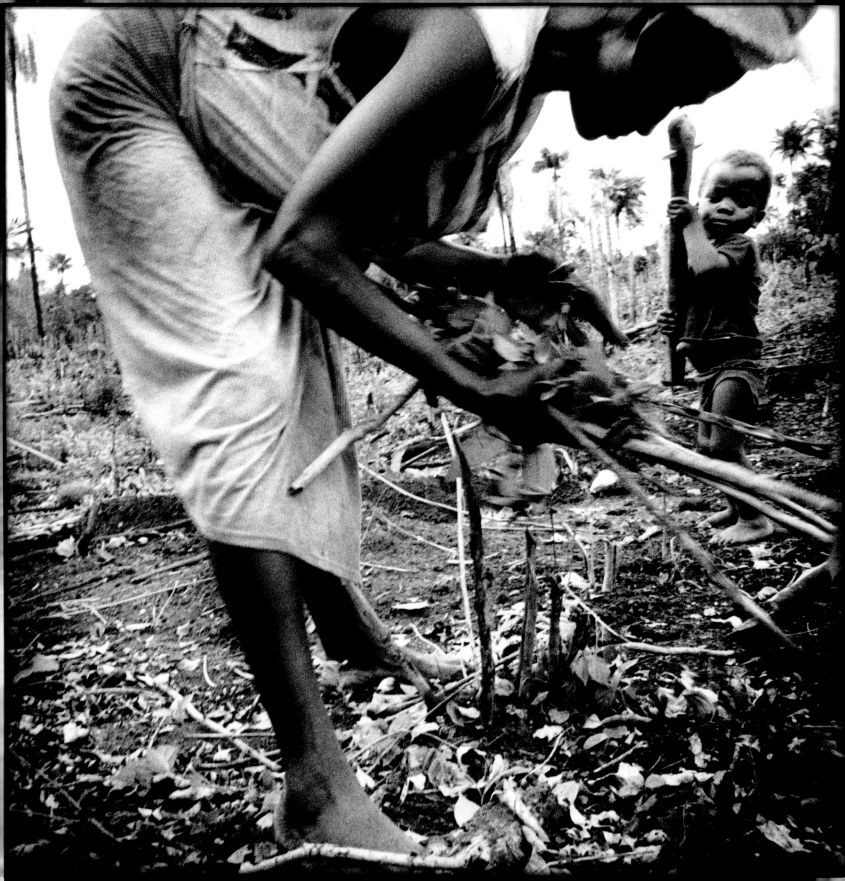

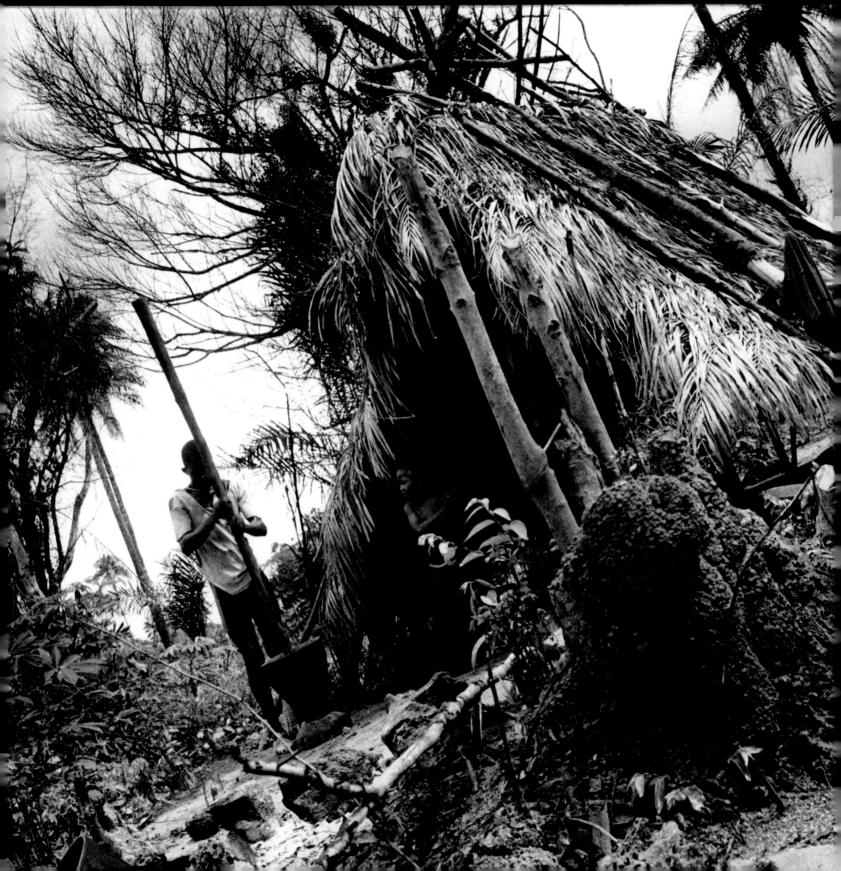

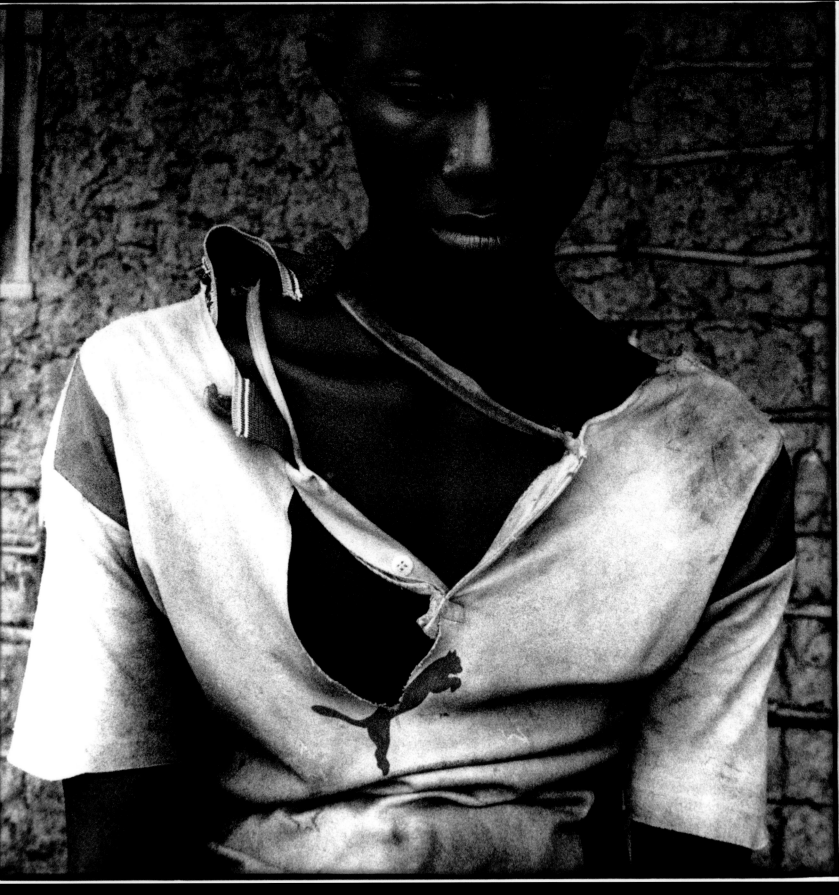

Morie

City of Rest

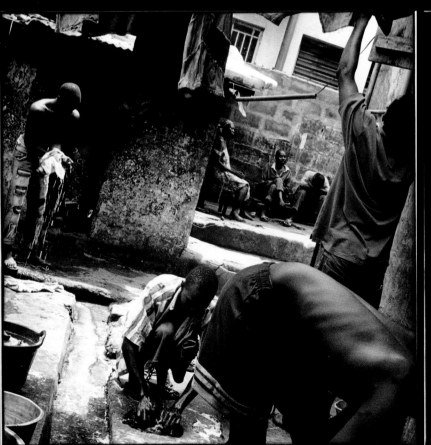
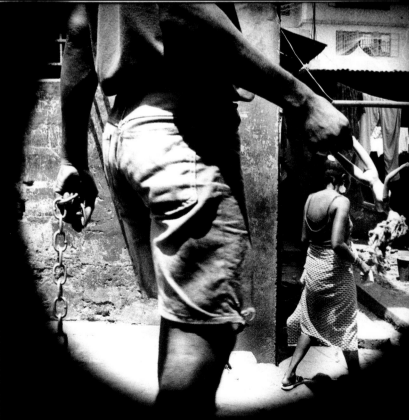

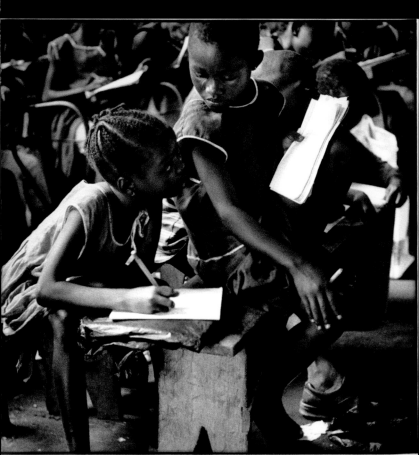

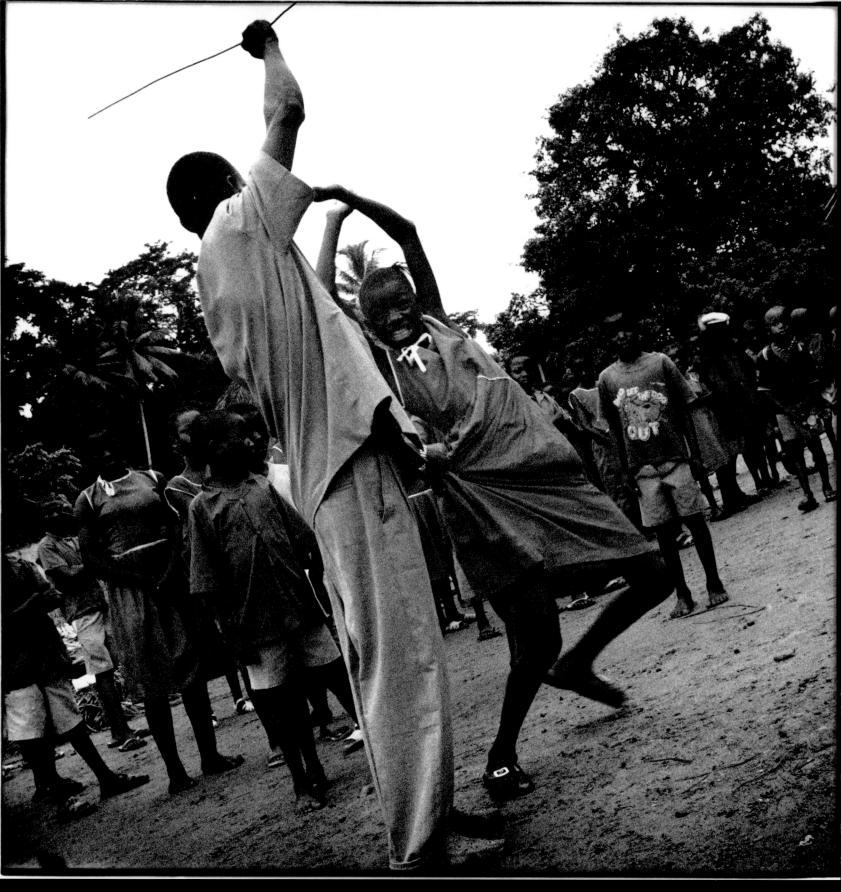

A girl is beaten because she arrived late at school

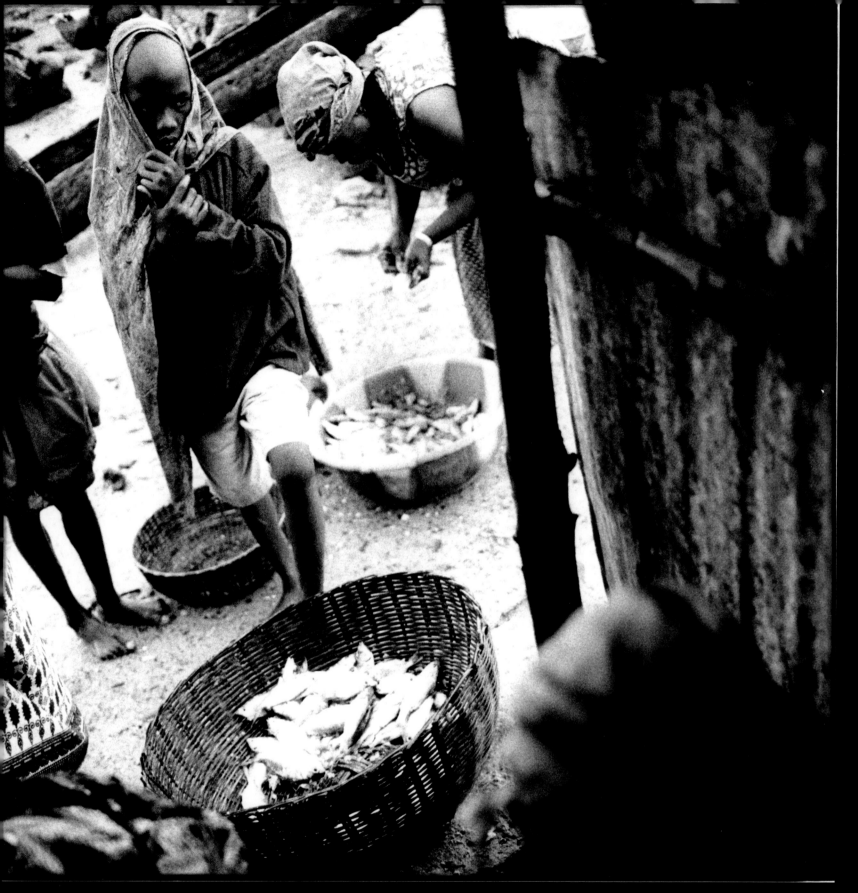

Selecting fish

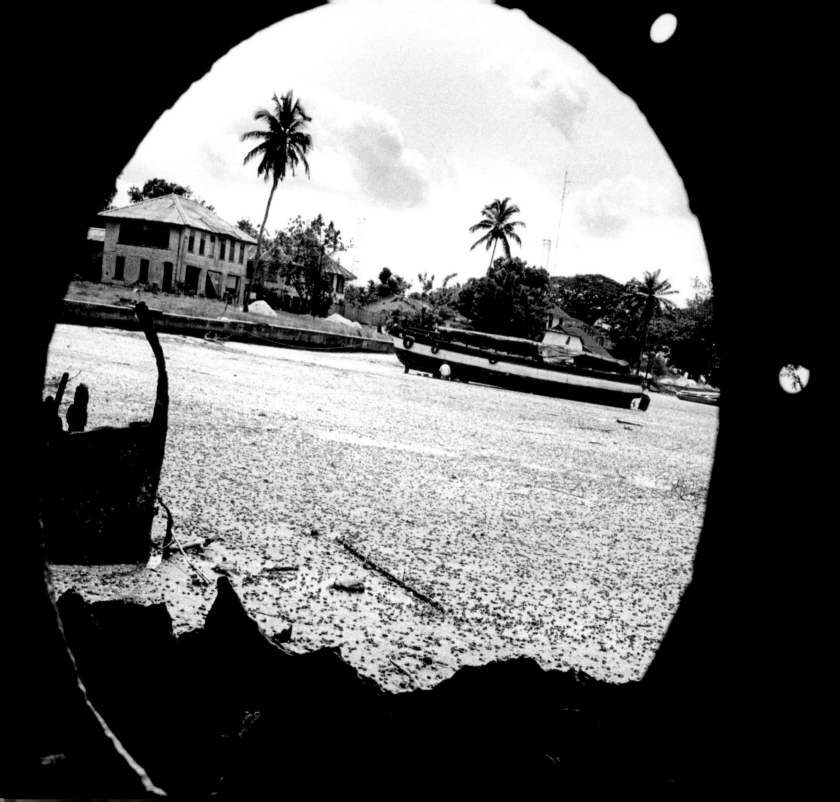

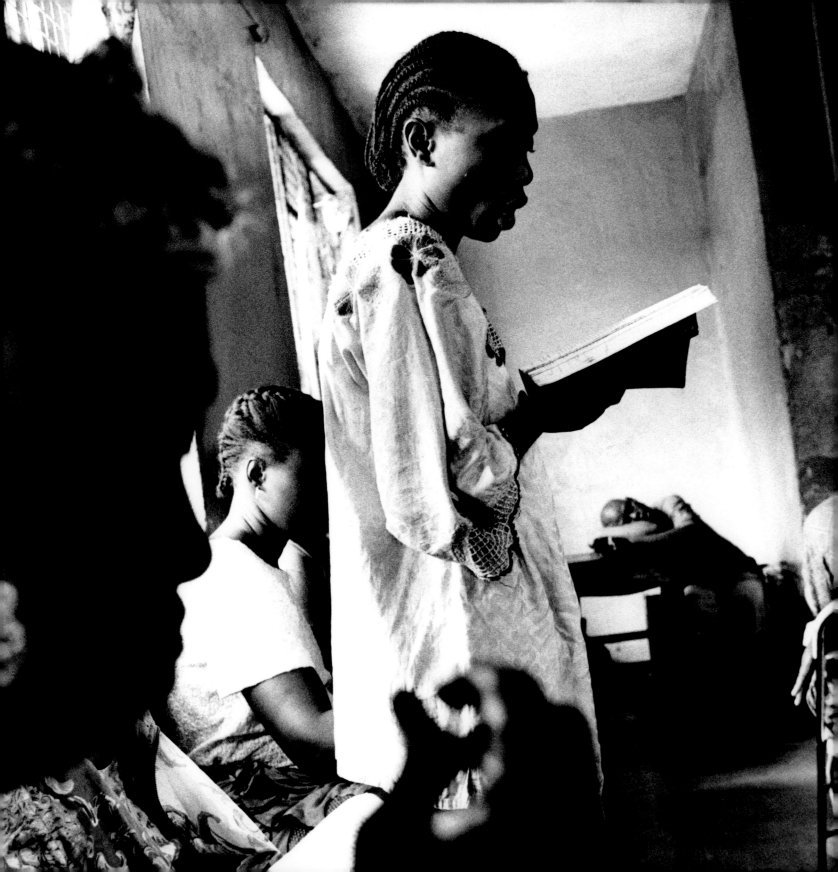

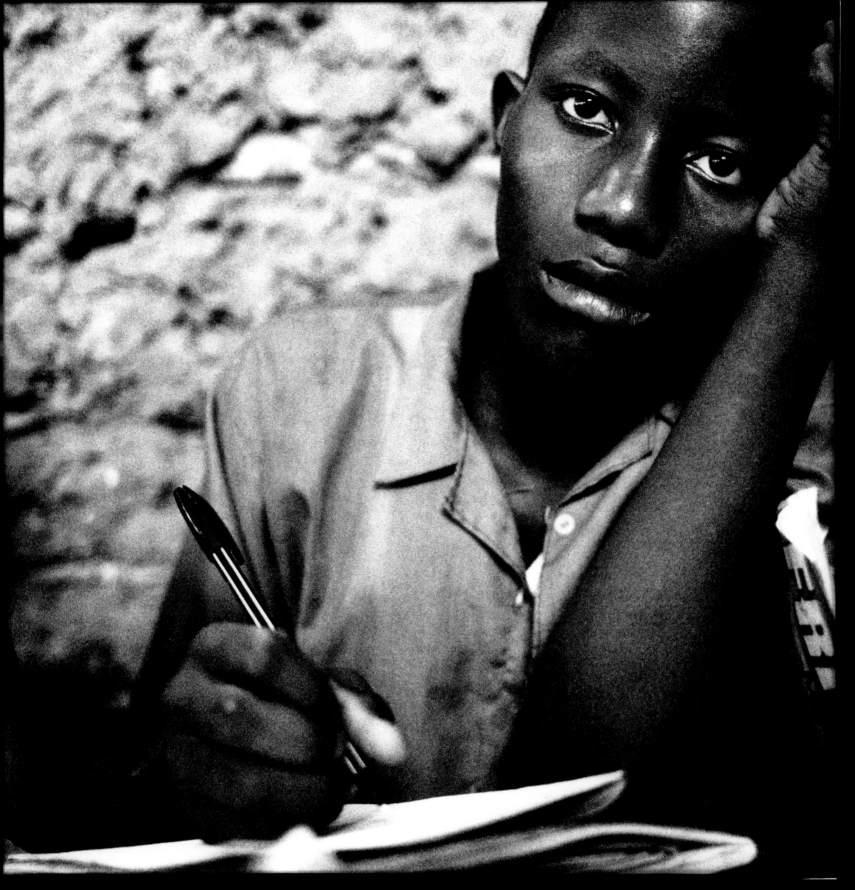

Morie

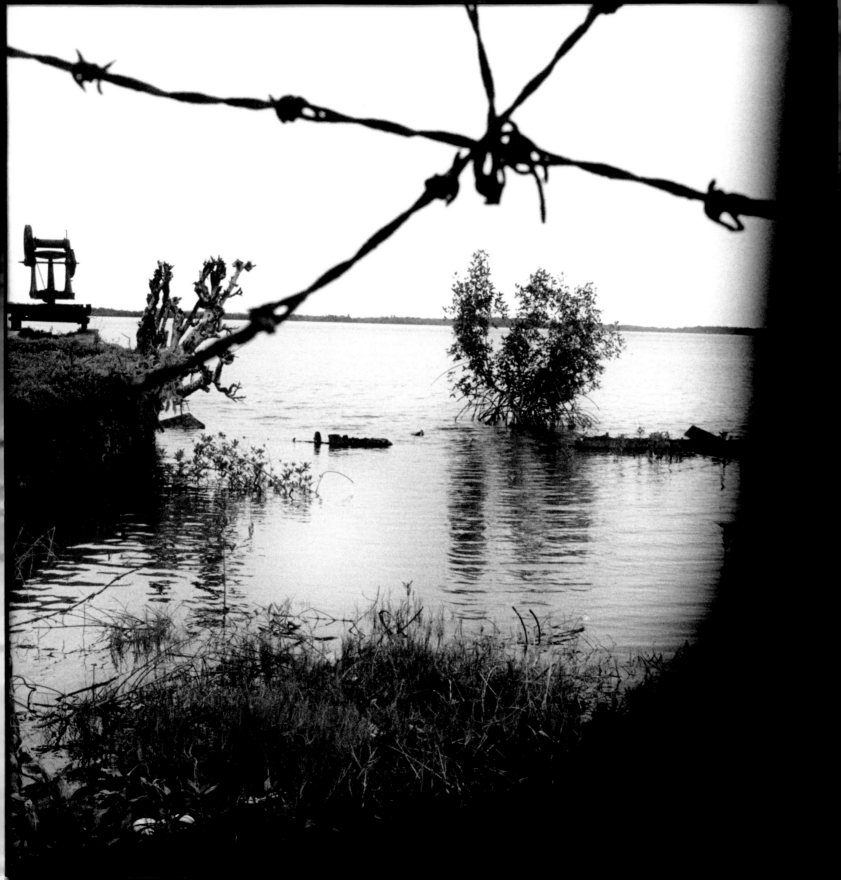

UXO IN LAOS:
REUSING THE RESIDUE OF THE SECRET WAR

Andrew Stanbridge

> In town there were bigger five hundred- to two thousand-pound bombs in front of restaurants and mixed in scrap yards.

I was sitting in a small noodle shop in Phonsovan, Laos, when American forces invaded Iraq at the beginning of Operation Iraqi Freedom in 2003. I had just spent the day wandering through the bomb crater pocked hillsides around the beautiful plains that the town is nestled in, looking to photograph various remnants of ordnance from a war that had some of its major battles fought over thirty years ago. And find them I did. Various models of cluster bombs, detonator caps, mortars and bullet casings all litter the hills. In town there were bigger five hundred- to two thousand-pound bombs in front of restaurants and mixed in scrap yards. So, here on the satellite TV, was the contemporary real time version of what I had been trying to imagine all day. The thunderous explosions, the people running to their houses or driving out of the city center, the tracer bullets cutting glowing lines through the sky. The knowledge that a way of life was beginning to change right in front of my and the other millions of viewers' and people experiencing the invasion's eyes. Yet, here I sat in a place that until Iraq surpassed it, was the most bombed country in the world, although few people know this fact as it was the site of one of the most secretive wars in history. I had been traveling to Laos for a couple of years, but until that moment I had no idea how much of a living history I was experiencing. I became aware of what a contemporary dialogue this small landlocked nation had with the current state of events unfolding in the middle east. From that moment on I decided to invest myself in learning more and documenting not only evidence of the war years of Laos, but to also unravel the events of rehabilitation, violence and recent economic development since the Pathet Lao and Vietnamese victory over the CIA-backed Hmong and Royal Lao resistance in 1973. In so doing, I now see that the moment of 'shock and awe' that I witnessed on the glowing screen above my bowl of noodle soup was – judging by the evidence of Laos – only the beginning of a long road of conflict, and eventually an even longer road of postwar reconstruction for Iraq.

A BRIEF BACKGROUND OF MODERN CONFLICT IN LAOS

In 1893 the French took control of the Kingdom of Laos as part of its colony building in Southeast Asia. This was to be the beginning of a long string of occupations and military involvement that inevitably involved nasty violence against the local population. In 1940 the Japanese took control of Laos after the Nazi defeat of France. More violence followed, along with the beginning of an alliance between the Hmong hill tribe people and the French to liberate themselves from the Japanese. This union would hold fast until 1953 when the French left Laos and their Hmong counterparts to cope with Viet Minh invasions in northeastern Laos. From 1953 until 1962 fighting continued with U.S.-supported Royalists and Hmong fighters battling intermittently with North Vietnamese troops. In 1962 Geneva Accords reaffirmed the neutrality of Laos and all foreign bases and troops were ordered to leave. The Vietnamese deny having any troops in Laos so no removal takes place. From 1962 until 1973 a secret war is fought in eastern Laos between the North Vietnamese Army (NVA) and a select group of CIA-backed flyers and ground support crews who ultimately rely on the Hmong people as their warriors. By war's end over two million tons of ordnance had been dropped on the country. Of this ordnance a good amount of it was in the form of cluster bombs, an estimated thirty percent of which did not explode on impact and continues to affect the daily routine of life in the affected provinces. In 1974 the last CIA-run Air America plane left Laos and thousands of its Hmong fighters behind to deal with the victorious NVA and Pathet Lao communist factions, much like the French had done twenty years before.

From this time until the present, the Hmong people have experienced ethnic cleansing and persecution of various means by the People's Democratic Republic of Laos, the government formed in 1975 and still in place. While this persecution continues Laos suffers as one of the poorest countries in the world, while having to deal with the remnants of a war ravaged landscape. Only in the past decade has foreign aid, tourism, copper and gold mining, timber sales and dam building projects allowed Laos to begin its economic expansion and therefore begin to modernize its society as a whole.

DOCUMENTING THE POST-CONFLICT ERA

After my noodle shop experience I got down to work, researching the most affected areas of the war, working on my Lao language skills and beginning to make connections at various government agencies that I hoped would help me gain more access to certain areas and information. I began at UXO Lao, the state run unexploded ordnance (UXO) clearing organization. Over the past two years I have gone out into the field with several of their teams to learn about the types of ordnance they deal with as well as their methodologies of slowly clearing the landscape of thirty-year-old explosives. From them I learned of the scrap metal industry that is quite prevalent in Laos. This industry involves local villagers going out to hunt for bombs, which they then defuse and take to small scrap metal yards, that in turn sell the scrap to larger metal smelting plants in Laos and Vietnam. Needless to say this is risky business for all involved and quite a few casualties ensue each year. The economy of recycling bombs intrigued me and so I began to seek out scrap yards and scrap collectors to photograph. Later I found out that most of the bombs that make it to the smelting factories are melted down and cast into rebar that is used in the construction of the new buildings that are popping up, thanks to the revitalization of the economy due to tourism. For me it was interesting how these bombs, that had become such a part of the landscape, were being used by the local population as a resource to be exploited for cash gain, and what they were willing to risk to attain this income. This led me to broaden my scope to various other economy building projects that are rooted in taking advantage of the Lao landscape. I really began working on this facet of post-conflict rebuilding this last summer by visiting a new Australian-run gold mine in the middle of the country, which employs mostly local workers, teaching them how to work the large trucks and other machinery necessary for a large scale mining project. I also began to photograph the logging industry, which mostly exports the wood to Thailand, as adequate milling facilities are not available in Laos.

It was at the gold mine and later at a relocation camp near a damming project that I noticed the extent to which the local villages are once again being exploited in a country that is trying to drag itself out of the shadow of war. And it is this concept that I wish to develop further with the backing of The Aftermath Project. I have now made contacts in all areas of government and private enterprises that will allow me access to the mining areas, dam building projects, continued work with UXO Lao and Long Tien, the former secret base of the CIA, which is just now beginning to open up for use with a new dam project as well as plans for an ecotourist destination, demonstrating once again how the remnants of war can be used as a cash crop. Of course, as in most cases of post-conflict rehabilitation, there are those who will benefit and those who will suffer through relocation and loss of land and waterways that they have based their way of life on for decades, if not centuries. It is this dichotomy that I wish to address in my work.

ການຂຸດປູ ຂຸດຂຽດ
ຖ້າບໍ່ລະວັງ ລະເບີດ

ຈະເປັນແບບນີ້ .

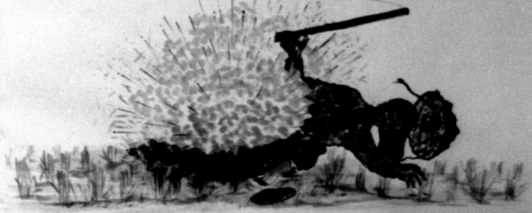

ຂ້າໄກ້

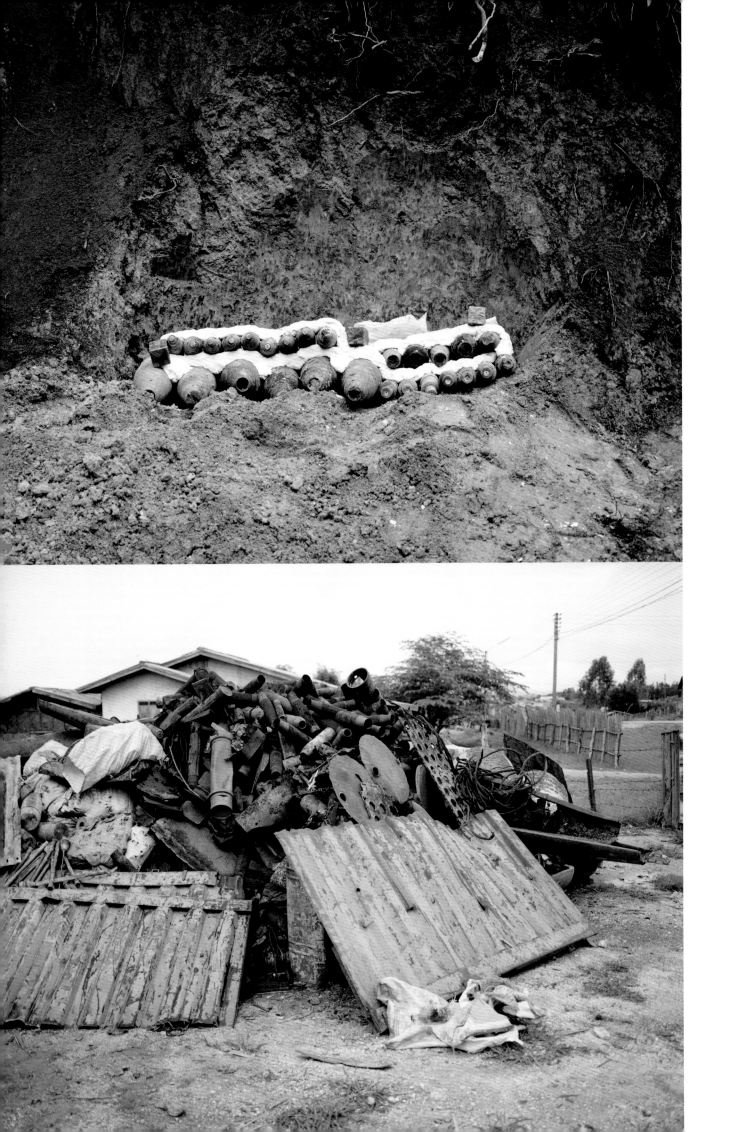

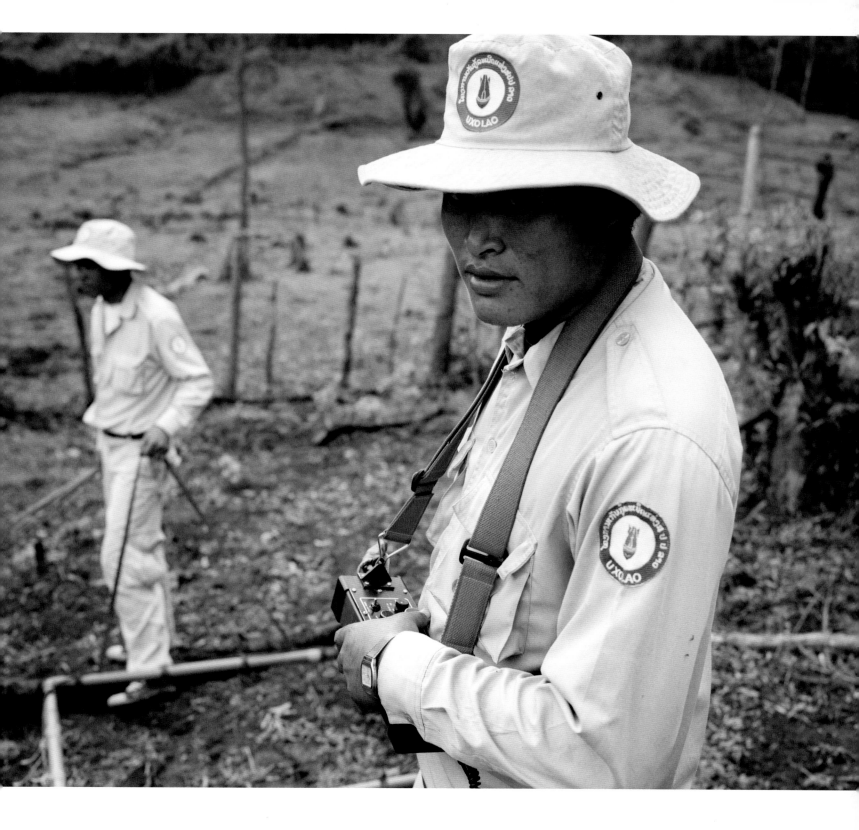

UXO Lao team members looking for UXO with large scale metal detector

< UXO ready to be detonated with c-4 plastic explosives

< Scrap yard

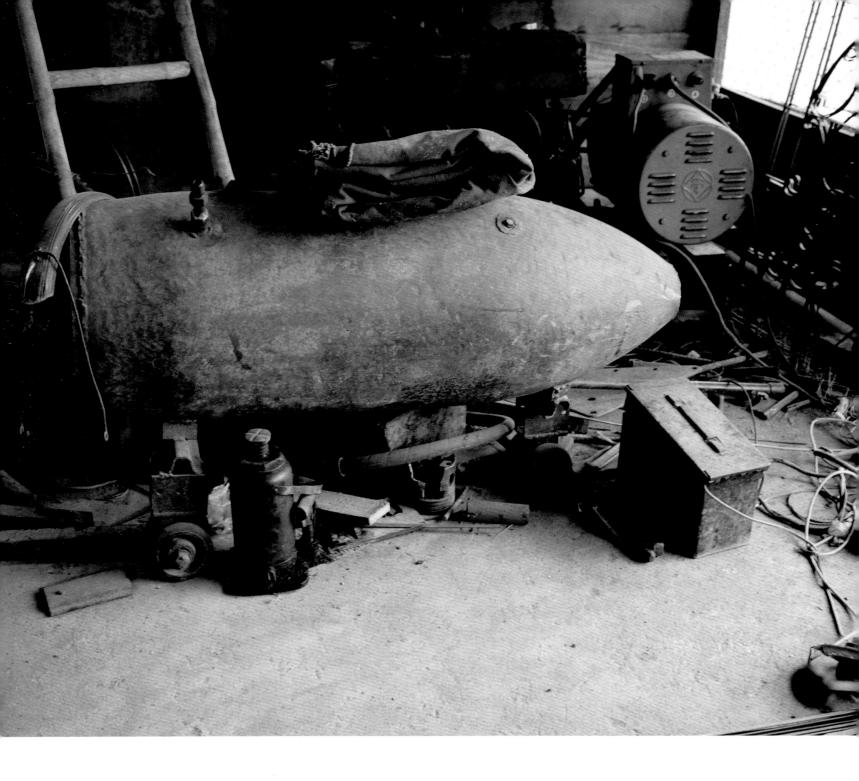

Bomb converted to air compressor

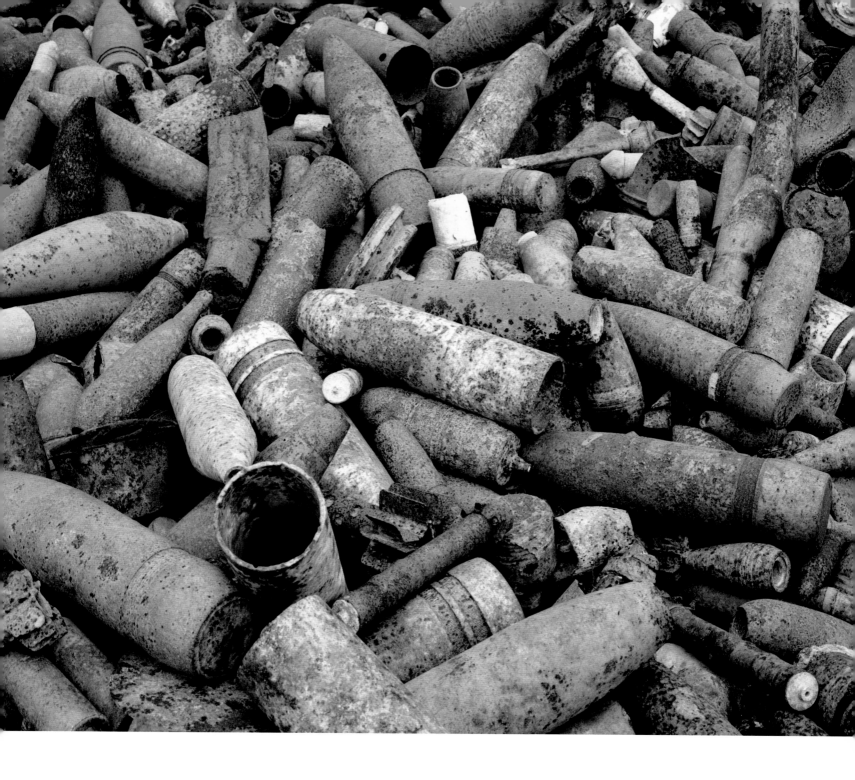

UXO that will be melted down into rebar

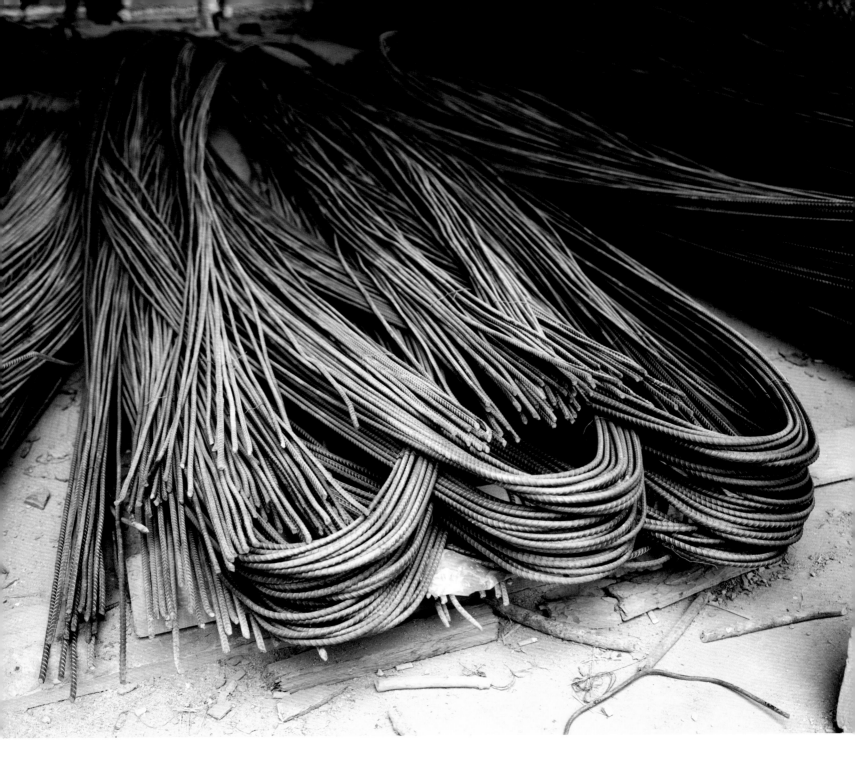

Rebar made from melted bombs

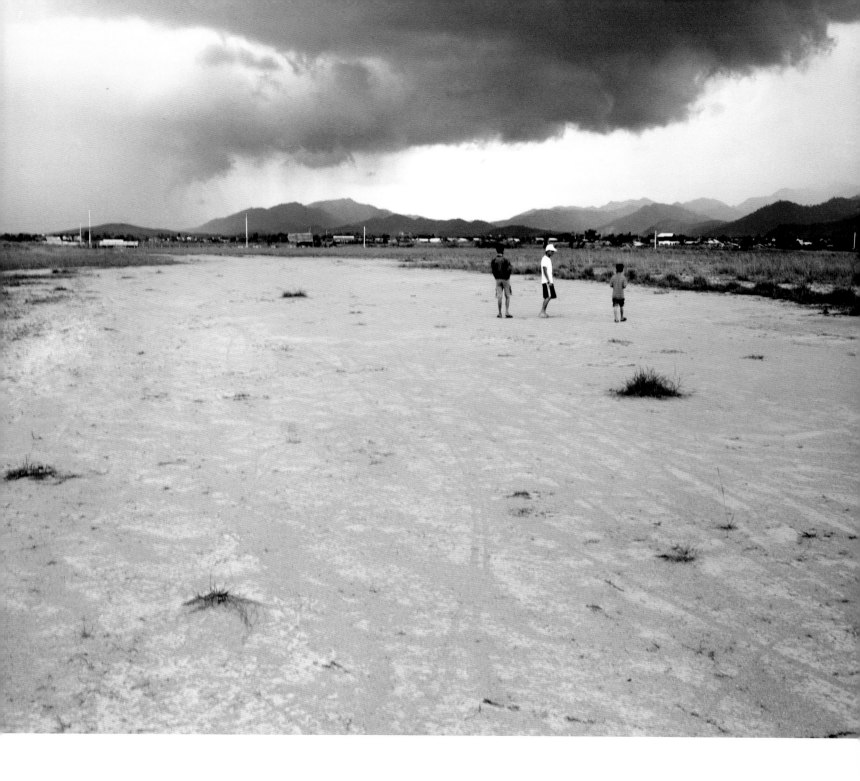

Old CIA site runway, now a fairway for an 'adventure golf course'

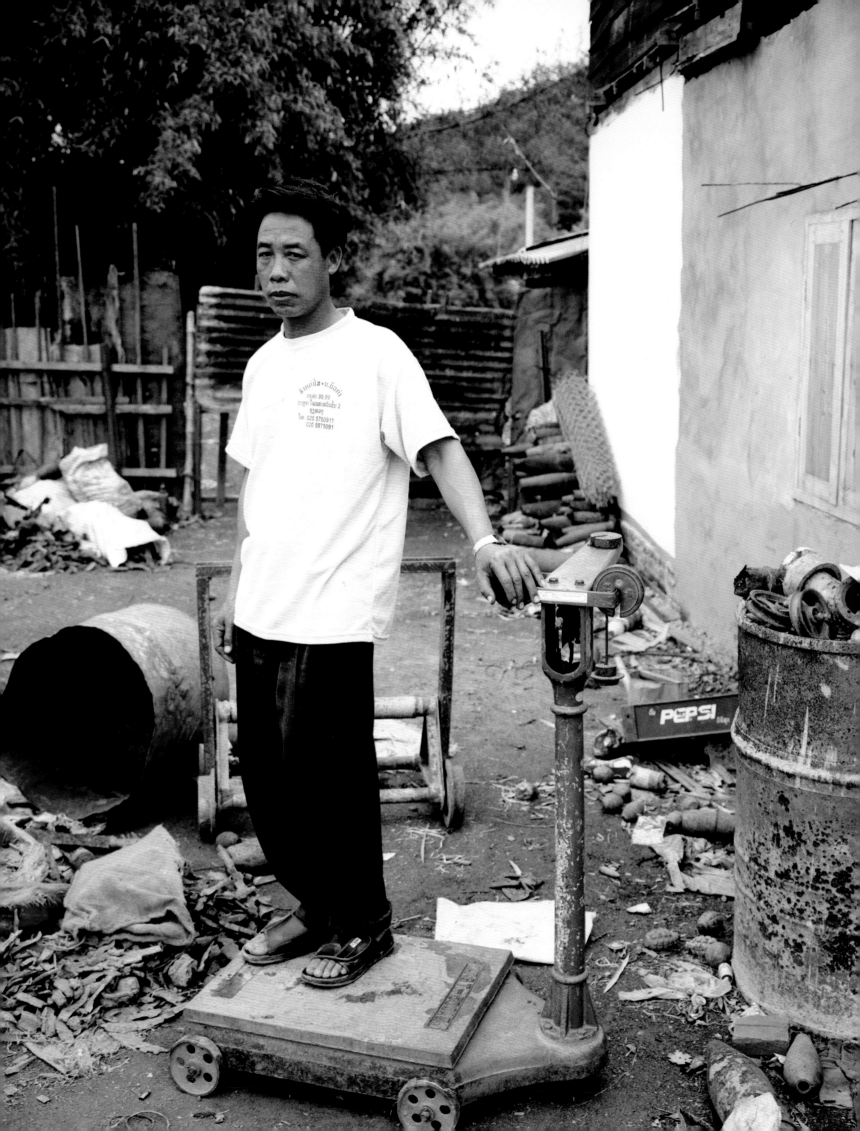

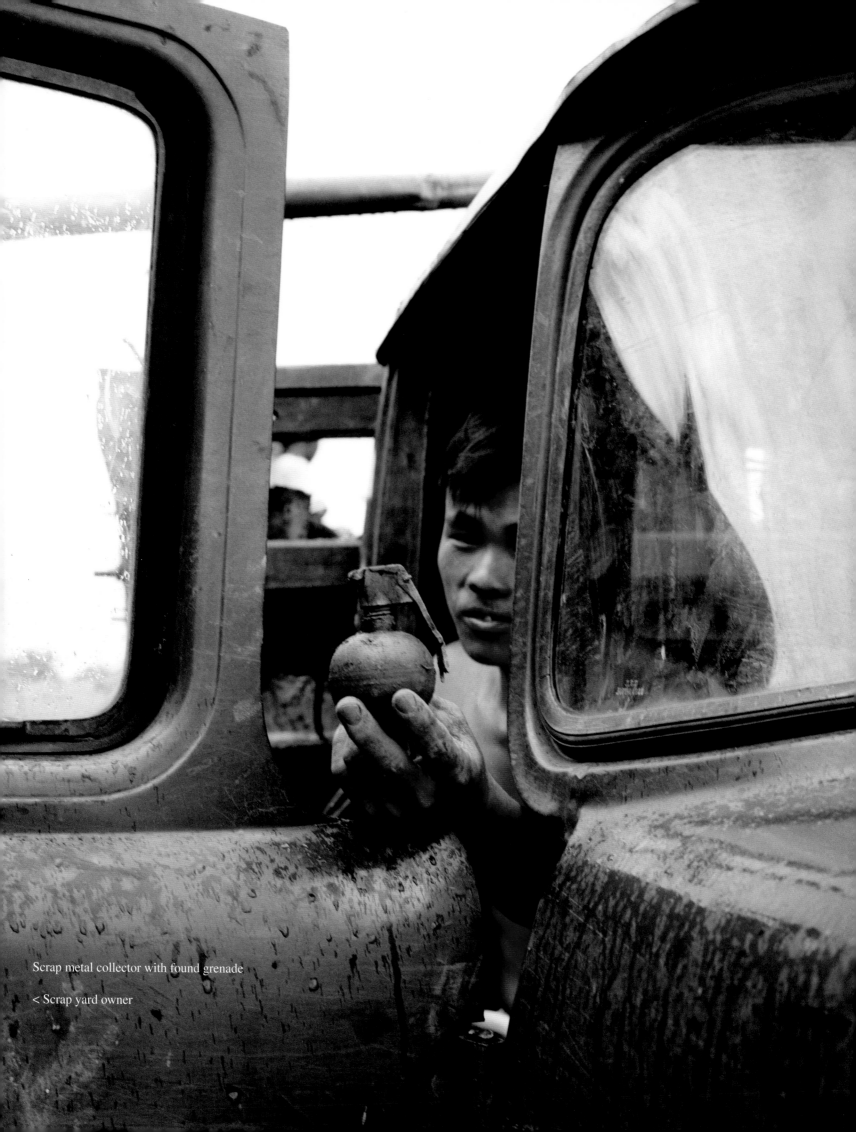

Scrap metal collector with found grenade

< Scrap yard owner

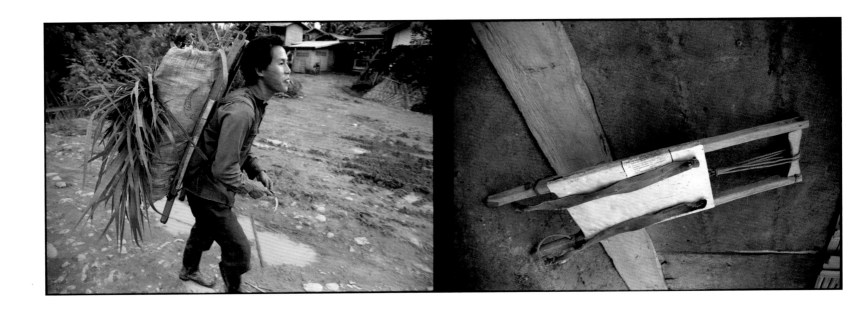

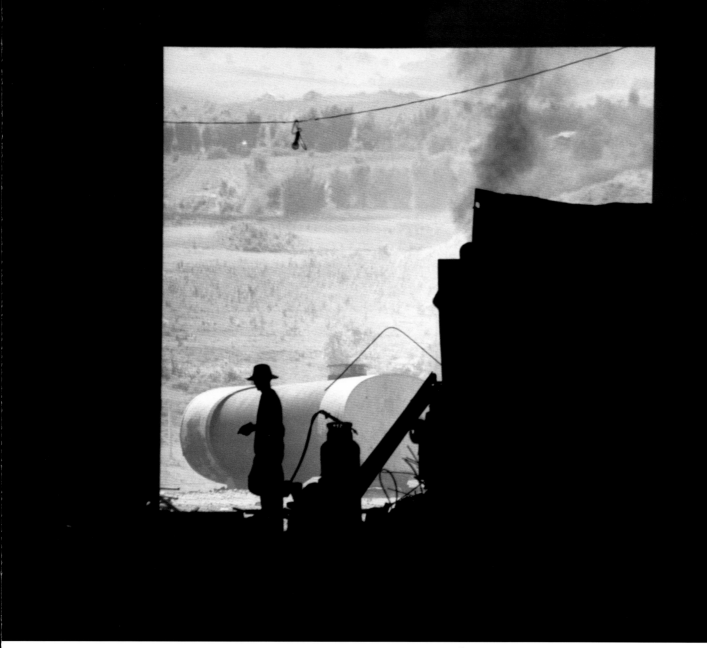

Smelting plant where old bombs are melted down to use in the fabrication of rebar

< Hmong man with vegetable carrier made with metal from crashed American airplane

EL LAMENTO DE LOS MUROS – ARGENTINA'S DIRTY WAR

Paula Luttringer

In the sixteenth and seventeenth centuries it was not unusual to see in *Cabinets de Curiosités* stones with strange patterns. It was thought that these patterns were created when the stones absorbed imprints of violence that had taken place nearby. I have a collection of these stones because they provide me with a metaphor for the marks I feel are inscribed in my own body and in the bodies of other Argentine women who, like me, suffered enforced disappearance and torture during Argentina's Dirty War thirty years ago. We lived through a storm of history that changed our lives. We have built our lives on the scars of that trauma, scars that left recognizable patterns on our lives and the lives of our children and loved ones. Since 2000, I have been going back to Argentina, returning to the Secret Detention Centers and photographing walls that still bear witness to the violence enacted on our bodies, searching for other women who lived through enforced disappearance, asking them to talk with me about memories that have lasted for thirty years. My project, called El Lamento de los Muros (The Wailing of the Walls), is the result.

... the marks
I feel are inscribed in
my own body and in
the bodies of other
Argentine women ...

Ants used to come in and out, and I would watch these ants because they were coming in and then going out into the world. They were walking across the earth, the outside world, and then coming back in again, and watching them I didn't feel so alone.

Ledda Barreiro was abducted on January 12, 1978, in Mar del Plata. She was then taken to the secret detention center 'La Cueva'.

I went down about twenty or thirty steps and I heard big iron doors being shut. I imagined that the place was underground, that it was big, because you could hear people's voices echoing and the airplanes taxiing overhead or nearby. The noise drove you mad. One of the men said to me: so you're a psychologist? Well bitch, like all the psychologists, here you're really going to find out what's good. And he began to punch me in the stomach.

Marta Candeloro was abducted on June 7, 1977, in Neuquen. She was then taken to the secret detention center 'La Cueva'.

It is very hard to describe the terror of the minutes, hours, days, months, spent there. At first when you've been kidnapped you have no idea about the place around you. Some of us imagined it to be round, others like a football stadium with the guards walking above us. We didn't know which direction our bodies were facing, where our head was, where our feet were pointing. I remember clinging to the mat with all my strength so as not to fall even though I knew I was on the floor.

Liliana Callizo was abducted on September 1, 1976, in Cordoba. She was then taken to the secret detention center 'La Perla'.

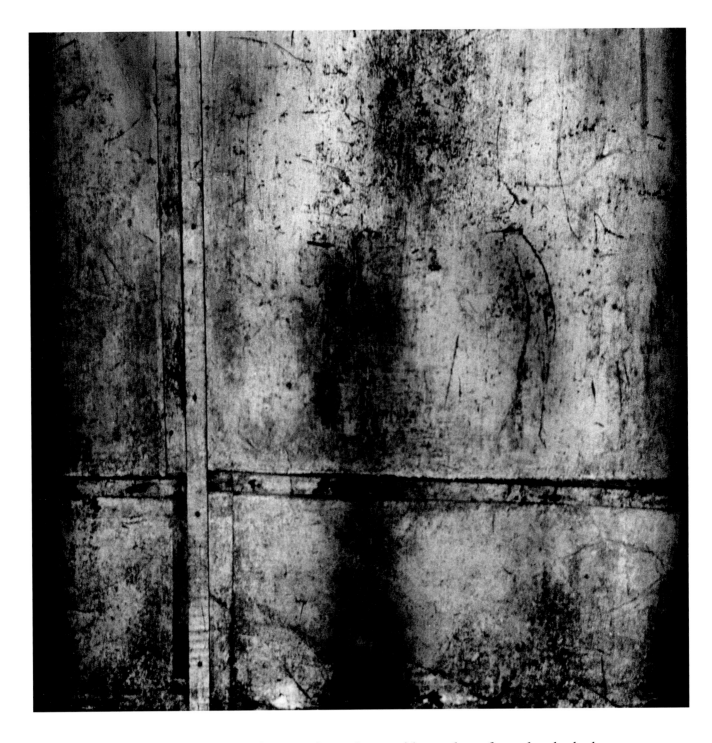

They said we were going to a place where we'd meet lots of people who had disappeared and about whom nothing more would ever be known, that we too had disappeared and no longer existed in the eyes of the world, that not even our names existed and that we should answer with the name they gave us. They left me handcuffed and blindfolded in a sort of courtyard, where they searched me and asked me about any metal objects I might be carrying, even if I had an IUD fitted. Later I found out that this routine was what they did before giving you electric shocks, to check that there was no other conductor on you.

Hebe Caceres was abducted on June, 1978, in La Plata. She was then taken to the secret detention center 'El Banco'.

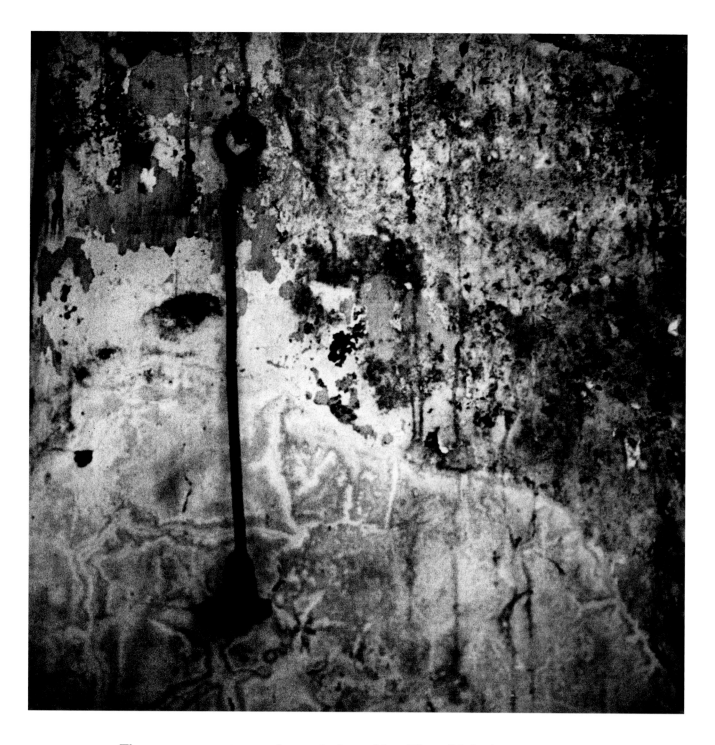

There were no cotton wads, no cloth; nothing. They didn't give you anything. When we had our period we would drip blood, and I'll never forget how they would drag us out into the corridor and beat our legs with sticks, saying: look how they drip and lose blood, just like dogs, just like bitches, leaving a trail of blood behind them.

Marta Candeloro was abducted on June 7, 1977, in Neuquen. She was then taken to the secret detention center 'La Cueva'.

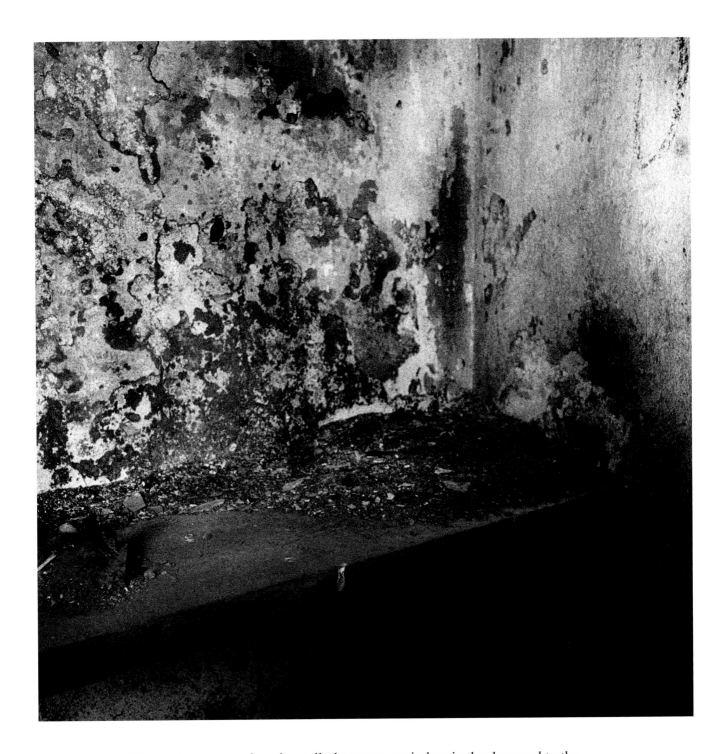

They put us women in a tiny cell; there was a window in the door and to the right there was a concrete seat. I remember this because when they came for us for another session I used to grab hold of the bench like a child, so as not to go.

Emilce Moler was abducted on September 17, 1976, in La Plata. She was then taken to the secret detention center 'Pozo de Arana'.

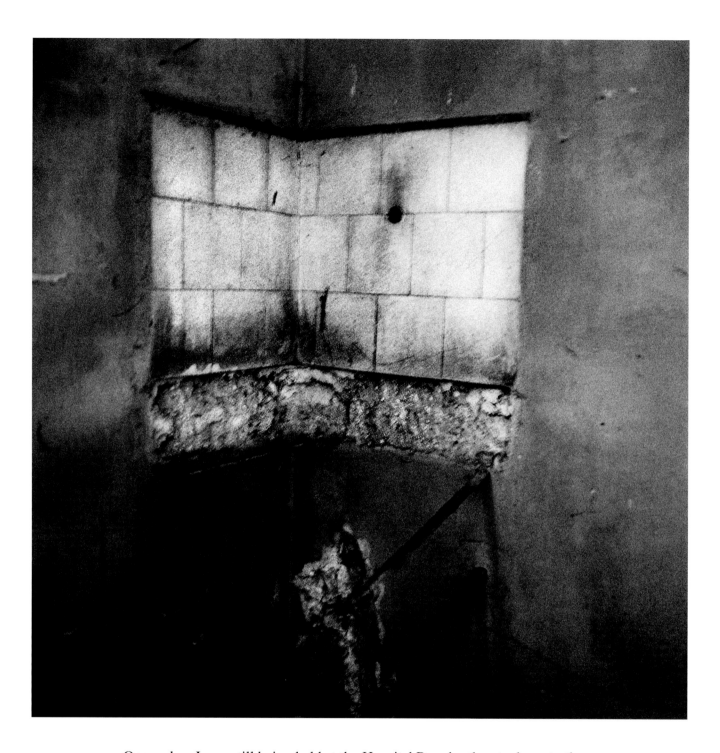

Once when I was still being held at the Hospital Posadas they took me to the bathroom. I took off the blindfold and looked at myself in the mirror: I didn't recognize myself and yet I knew it was me. I looked at the face staring back at me and said 'that's not me'. There was fear in my eyes; it was the look of someone cornered, a terrible staring, as if waiting for the next blow.

Gladis Cuervo was abducted on noviembre 25, 1976, in Buenos Aires. She was then taken to the secret detention center 'Hospital Posadas'.

Immediately after my arrival at La Perla I was taken to the torture room. They striped me and tied my feet and hands with ropes to the bars of a bed, so that I was hanging from them. They attached a wire to one of the toes of my right foot. Torture was applied gradually, by means of electric prods of two different intensities: one of 125 volts, which caused involuntary muscle movements and pain all over the body, and another of 220 volts called la margarita (the daisy), which caused a violent contraction – as if they were ripping off all your limbs at the same time. I tried to kill myself by drinking the filthy water from this can they used for another kind of torture called 'ducking', but I didn't manage it.

Teresa Meschiati was abducted in the town of Cordoba on September 25, 1976, in Cordoba. She was then taken to the secret detention center 'La Perla'.

The first sensation of being naked, which made me feel very ashamed, was nothing next to being tortured. It was completely shameful that those men were engaged in an act of torture – not that they were torturing me, but that they were torturing...

Isabel Cerruti was abducted on July 12, 1978, in Buenos Aires. She was then taken to the secret detention center 'El Olimpo'.

Something strange used to happen at night, the screams of torture were different than those during the day. Even if the screams of torture are always the same they sound different at night. And it's also different when they come to get you at night. The noises and the screams are not with me always, but when I do remember them, it makes me very sad. I am paralyzed by those screams, I'm back in that time and place. As somebody once said – and I've given this some thought and I think it's right – although life goes on, although some of us were freed, you never get out of the pit.

Isabel Cerruti was abducted on July 12, 1978, in Buenos Aires. She was then taken to the secret detention center 'El Olimpo'.

How could they not hear the screams if the torture room was next to the street? Timidly at first, the neighbors began to speak: one saw cars entering and leaving; a carpenter heard the screams; and somebody else said that he noticed when they covered the front windows. Going to see those neighbors so long afterwards was incredible. I said to them: 'I'm talking to you about the ghosts from the inside, and you are talking about the ghosts from outside. Do you realize that we are all victims, that there are no differences between you and me? I may have suffered physically, but in terms of experiences we were those on the inside and those on the outside.'

Isabel Fernández Blanco was abducted on July 28, 1978, in Buenos Aires. She was then taken to the secret detention center 'El Olimpo'.

Obviously, in every society these appalling things can happen at some point or another. I don't think there's a society where it would be impossible for this to happen. It doesn't exist; it's just a fantasy or wish of those people who believe they live in societies where it couldn't happen... Perhaps in order to talk about it you'd need to feel more secure. As soon as you beguin to feel a bit rejected, you too close yourself off. So it's like a vicious circle, a dog chasing its tail. And what does all this contribute to the cloak of silence.

Liliana Gardella was abducted on November 25, 1977, in Mar del Plata. She was then taken to the secret detention center 'Esma.'

Fear And Bloodshed In Haiti

Asim Rafiqui

In early 2005 I traveled to Haiti to document what promised to be a new era in Haiti's troubled history. The departure of Jean-Bertrand Aristide in the face of a 'popular' armed rebellion seemed to offer the possibilities of renewed hope for this wounded land and its people. The international community had welcomed Aristide's removal and promised much needed financial and political support. In the aftermath of the chaos that had gripped the nation during the rebellion, there seemed to be a genuine promise of change and restart. The reality that I found there, however, was not what I had been led to believe. I witnessed an ongoing campaign of violence and repression by Haiti's new leaders, installed by the U.S. and France, to eliminate the still popular Lavalas (pro-Aristide) movement and its supporters. Hundreds of Lavalas activists were locked without charge in jails, while hundreds of others were killed while protesting in the streets or during Haitian National Police (HNP) raids into strongly pro-Aristide neighborhoods. Entire communities suspected of pro-Aristide leanings had been surrounded by MINUSTAH, the United Nations Stabilization Mission in Haiti, as well as HNP checkpoints, and the residents denied services like water and electricity. The international community, particularly the U.S. and France, was standing firmly behind the 'interim' government. The U.S. had even restarted economic and military aid to this government. This was in sharp contrast, I later learned, to its attitude toward the democratically elected President Aristide whom it placed under economic sanctions in 1995 and then worked tirelessly to topple by funding and courting his opponents. The sanctions withheld nearly $500 million from one of the poorest nations in the Western Hemisphere and caused severe social and economic devastation in the country. At the same time the U.S. government provided financial and political support to Aristide's opponents and even arranged conferences in neighboring Dominican Republic for Aristide's opponents to meet those from Washington who shared similar political views. As Amy Wilentz, a journalist with extensive experience in Haiti, wrote in the *Nation*: 'In a country [...] where the military has been disbanded for nearly a decade, soldiers don't simply emerge [...] they have to be reorganized, retrained and resupplied [...] and someone has to organize [them].' The 'interim' government, consisting of a group of business-industrialist elite, had set about dismantling the social and political institutions that Aristide had implemented during his rule. Hundreds were suddenly jobless and unable to feed their families. Many of these business-industrialist elite were once part of the

'The government believes it is essential that Haiti have a hopeful future. This is the beginning of a new chapter.' – President George Bush February 2004, after the departure of Jean-Bertrand Aristide

brutal Duvalier regime and are now back, dressed as the new democrats. MINUSTAH had been given a 'peacekeeping' task for which it was clearly undermanned and unprepared. Meanwhile it had become a collaborator in the ongoing campaign of repression. And yet, further pressure was being put on MINUSTAH to use greater force, compelling the Commander of the UN forces, General Augusto Heleno Ribeiro, to complain that, 'We are under extreme pressure from the international community to use violence. I command a peacekeeping force, not an occupation force.' Sometimes the aftermath of conflict can be even more dangerous than the conflict itself, as it takes place away from the eyes of the press and under the noses of the international community. At moments such as this, as in Haiti that summer of 2005, the slogans and promises may be of peace, but the reality remains one of fear and bloodshed.

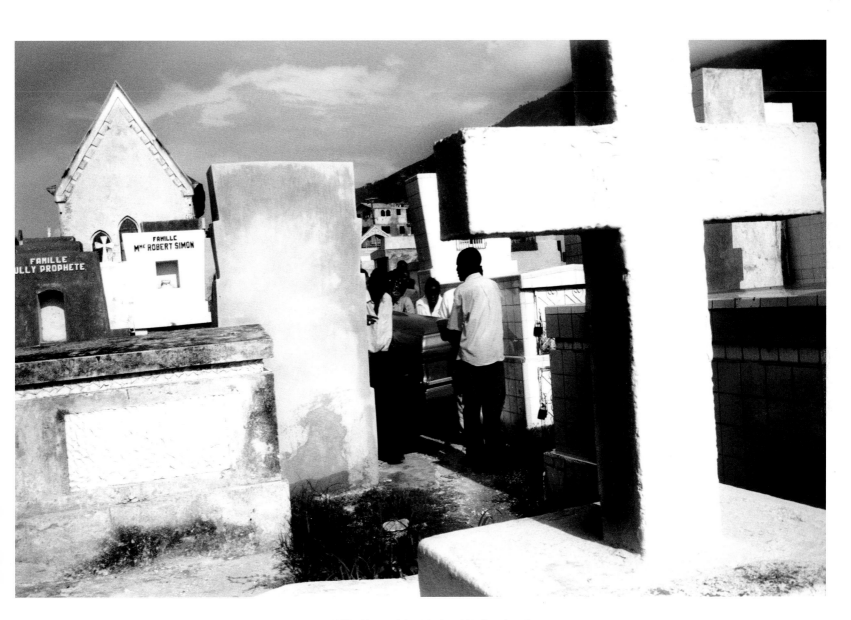

Mesnal Delarge, a Lavalas activist who was shot and killed by Haitian National Police (HNP) while participating in a pro-Aristide rally, is laid to rest by members of his family

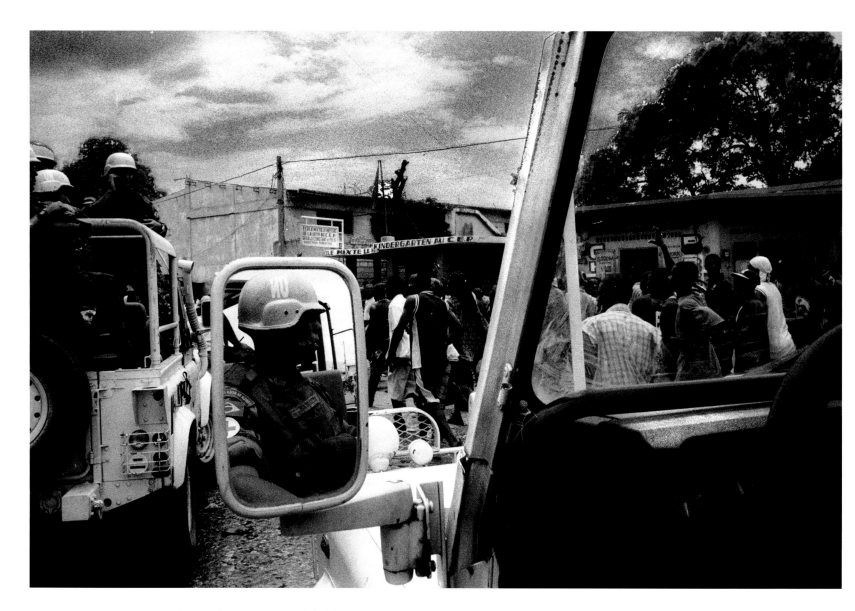

MINUSTAH troops keep a close eye on pro-Aristide supporters as they march through the streets of Port-au-Prince

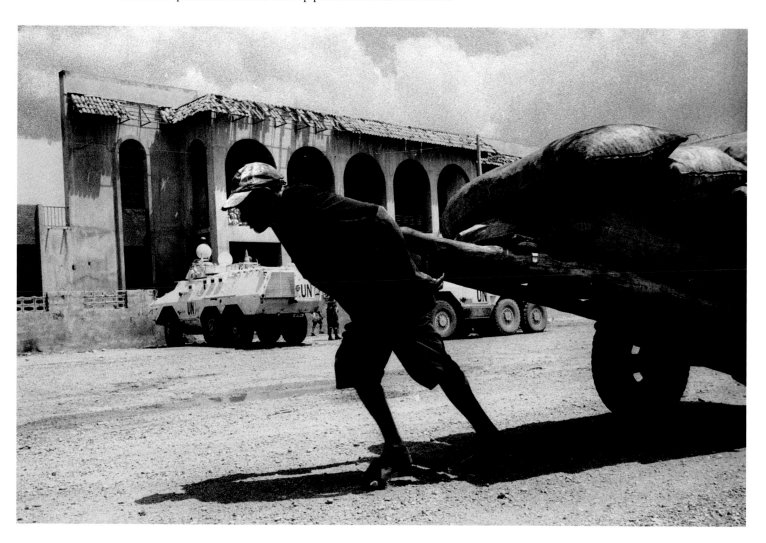

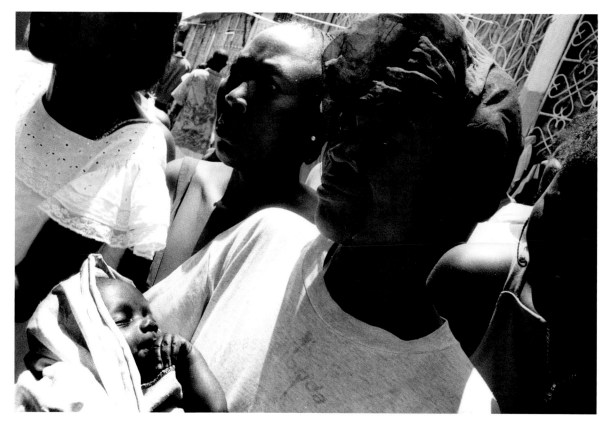

Marie-Maude Fabien's family weeps as they are informed of her death
from stray bullets during a MINUSTAH operating inside Cité-Soleil

A victim of a gun battle between MINUSTAH forces and local armed men lies on a road side near Cité-Soleil

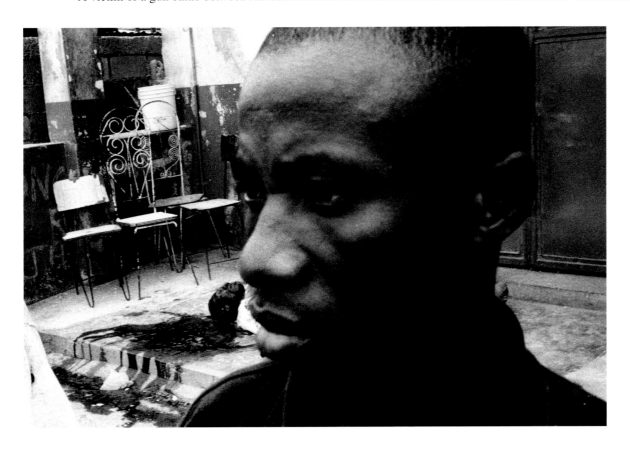

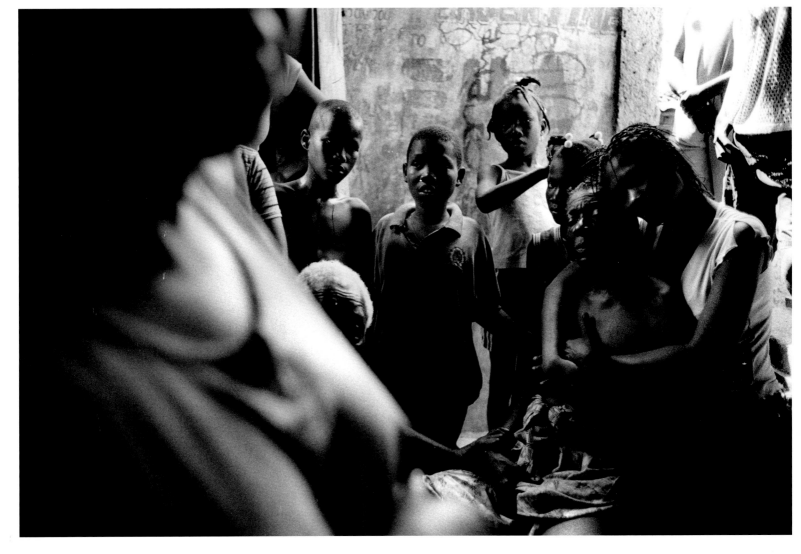

Paula Anne Sylvina mourns the critical wounding of her daughter Jordan Josette
during a HNP death squad operation in the slum of Bel Air

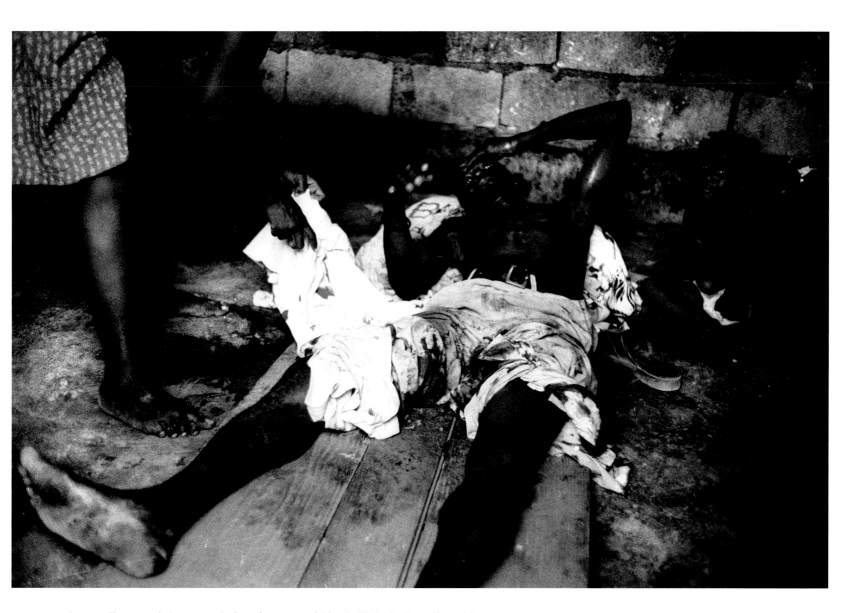

A mortally wounded man, a victim of an HNP raid in the Bel Air slum, lies without any medical assistance in a secret location to avoid being arrested or killed

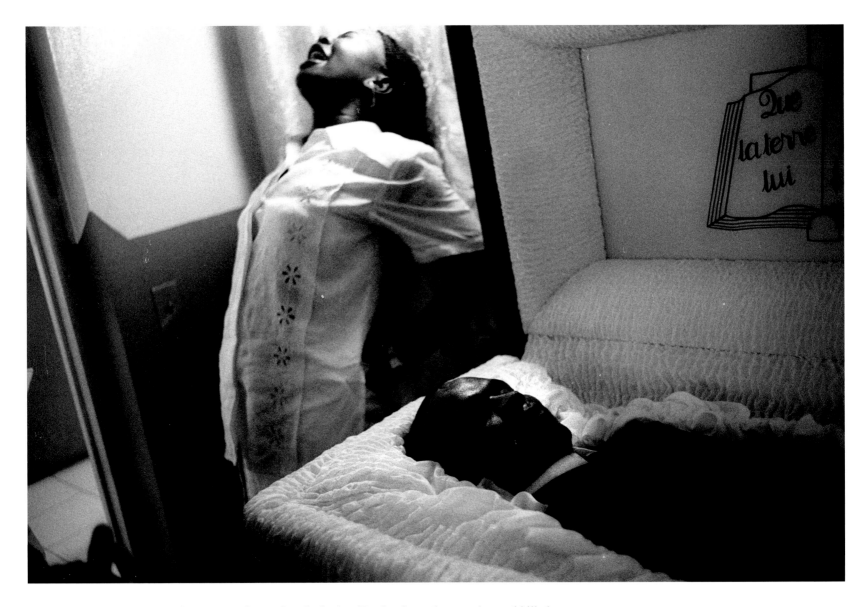

Mesnal Delarge's sister reacts after seeing the body of her brother, who was shot and killed by HNP gun fire while participating in a pro-Aristide rally in Port-au-Prince

An HNP team, working in close coordination with MINUSTAH, prepares to enter the 'Boston' neighborhood of Cité-Soleil

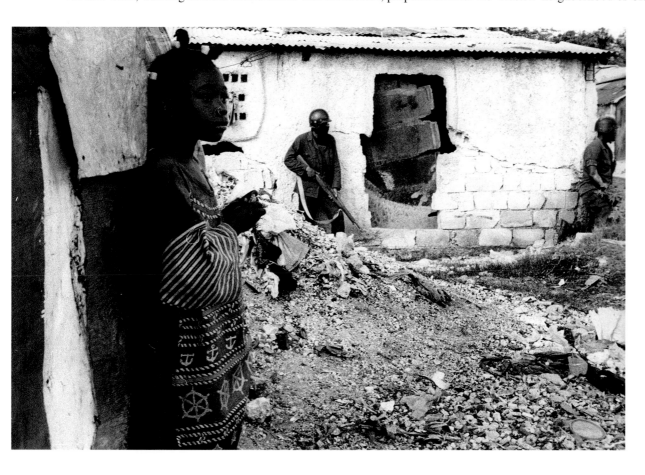

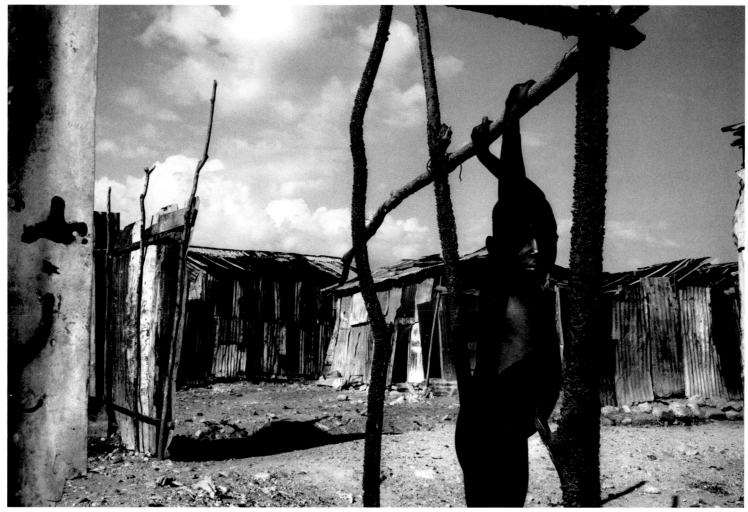

Children play among sheet metal homes in Cité-Soleil

A wounded man, shot during an HNP operatiom inside Bel Air, is taken to a hide-out to avoid being arrested or killed

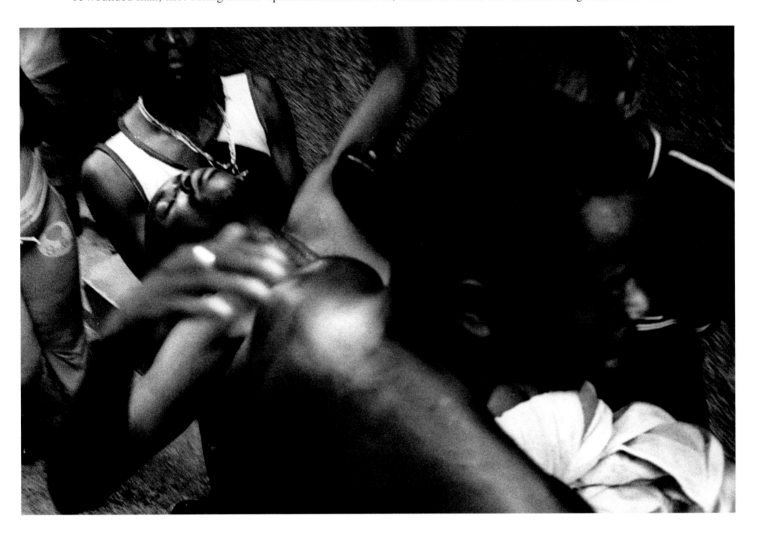

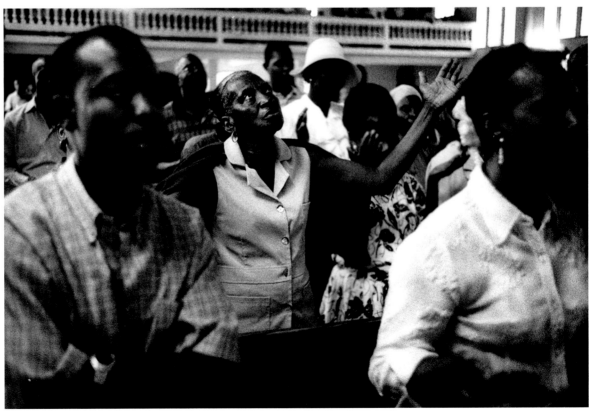

Worshippers at St. Claire, father Gerard Jean-Juste's church in Port-au-Prince

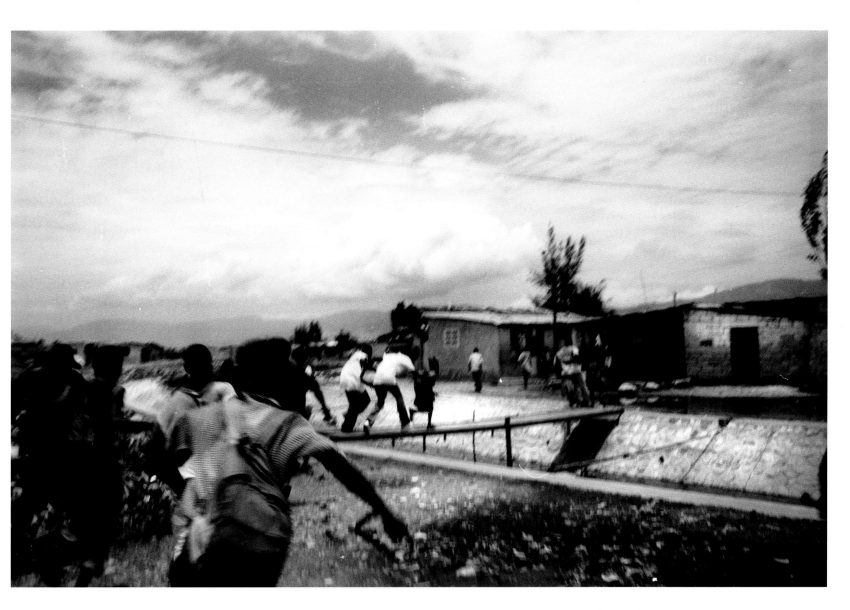

People scramble to escape gun fire from HNP, directed at a pro-Aristide march as it made its way into Cité-Soleil

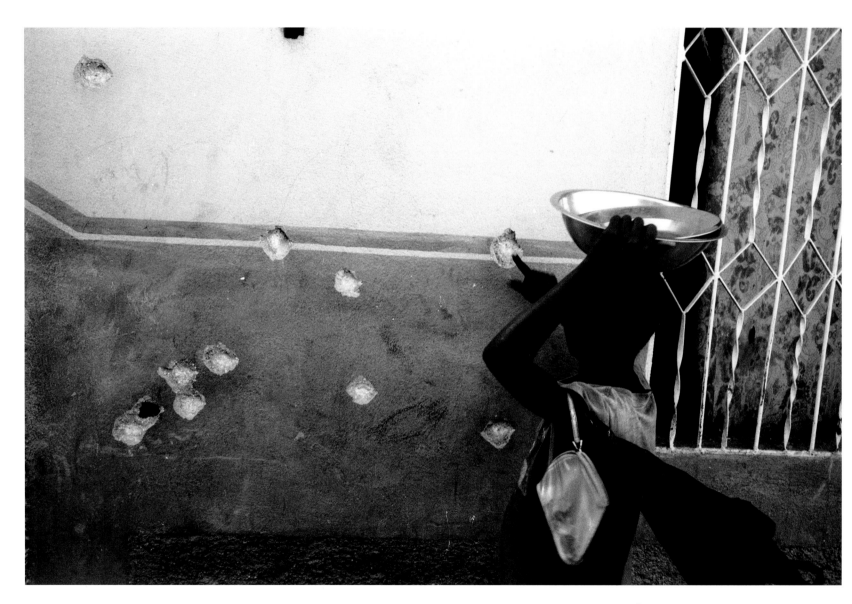

A girl walks past a house riddled with bullet holes; MINUSTAH machine gun fire can be seen in densely populated neighborhoods

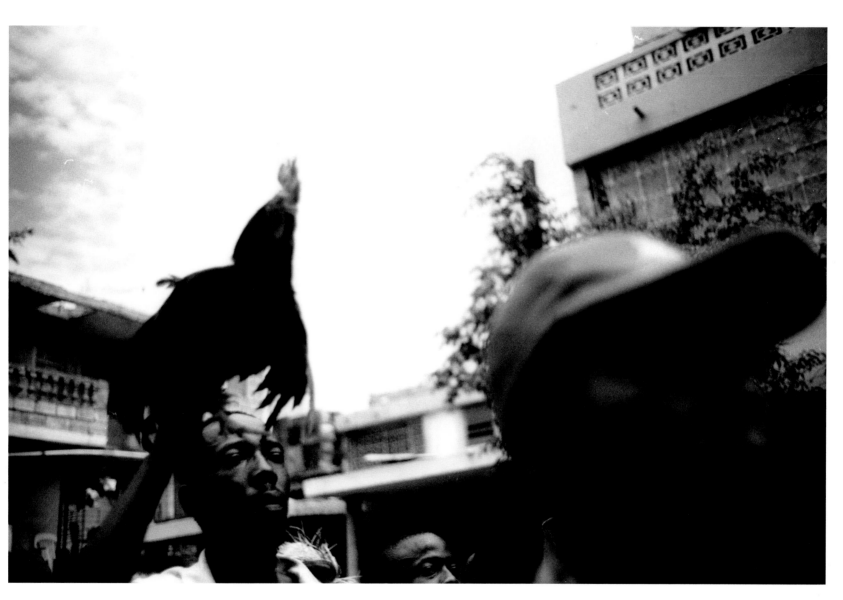

Voodoo ceremonies take place before the start of a pro-Aristide demonstration in Bel Air to help protect the participants from gun fire and injury

Front cover: Jim Goldberg

This project was made possible, in part, through the generous support of The Paul Strand Trust for the benefit of Virginia Stevens.

Design: Teun van der Heijden, Heijdens Karwei, Amsterdam
www.heijdenskarwei.com

The staff for the Aperture edition of WAR IS ONLY HALF THE STORY: THE AFTERMATH PROJECT includes: Lesley A. Martin, Publisher, Books; Susan Ciccotti, Managing Editor, Books; Matthew Pimm, Production Director; Christy Wiles, Work Scholar

First Aperture edition
Printed by Wachter GmbH, Bönnigheim, Germany
10 9 8 7 6 5 4 3 2 1
This volume was printed on BVS (interior 150 grams, cover 300 grams) from Papierfabrik Scheufelen GmbH, Lenningen, Germany.

Library of Congress Control Number: 2008920578
ISBN 978-1-59711-042-6

Aperture Foundation books are available in North America through:
D.A.P./Distributed Art Publishers
155 Sixth Avenue, 2nd Floor
New York, N.Y. 10013
Phone: (212) 627-1999
Fax: (212) 627-9484

This volume is distributed in the United Kingdom by:
Thames & Hudson
181A High Holborn
London WC1V 7QX
United Kingdom
Phone: + 44 20 7845 5000
Fax: + 44 20 7845 5055
Email: sales@thameshudson.co.uk

aperturefoundation
547 West 27th Street
New York, N.Y. 10001
www.aperture.org

The purpose of Aperture Foundation, a non-profit organization, is to advance photography in all its forms and to foster the exchange of ideas among audiences worldwide.